Painting
Mood and Atmosphere

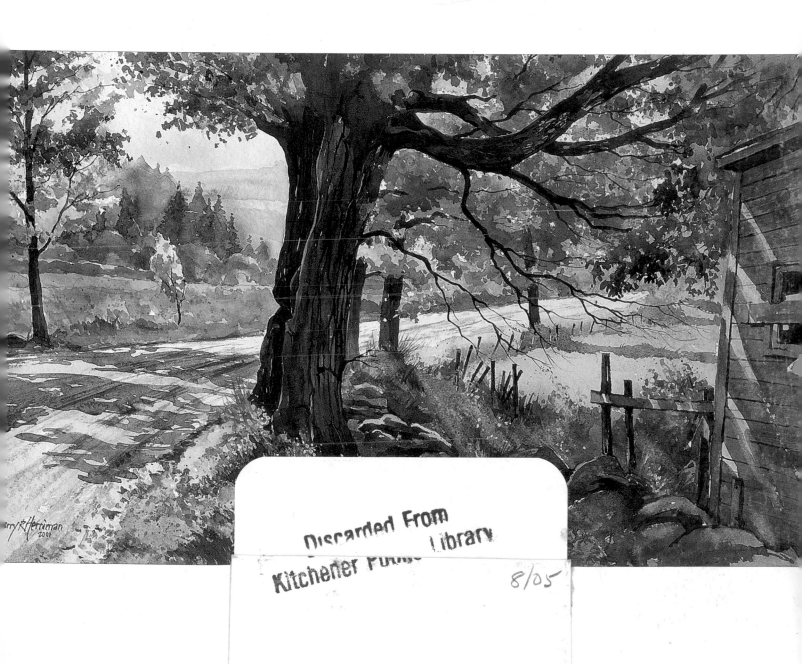

8/05

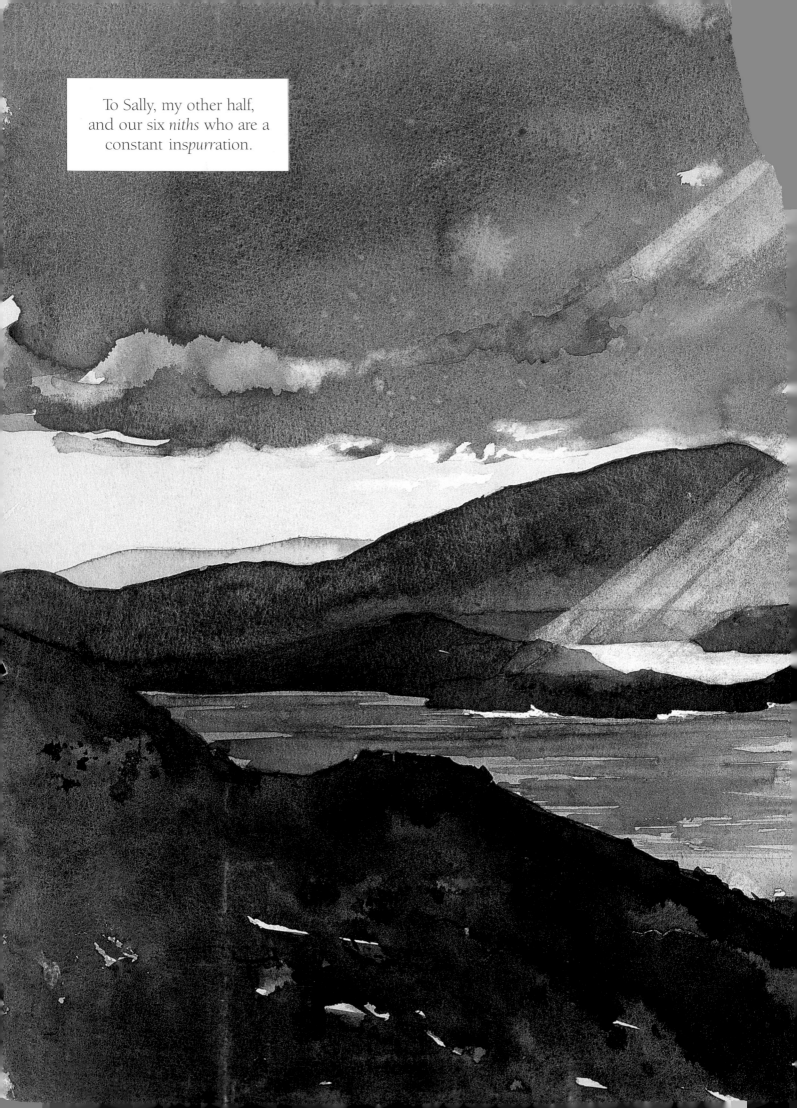

To Sally, my other half,
and our six *niths* who are a
constant ins*purr*ation.

Painting
Mood & Atmosphere

BARRY HERNIMAN

SEARCH PRESS

First published in Great Britain 2004

Search Press Limited
Wellwood, North Farm Road,
Tunbridge Wells, Kent TN2 3DR

The publishers would like to thank Winsor & Newton for
supplying some of the materials used in this book.

Suppliers
If you have difficulty in obtaining any of the materials and
equipment mentioned in this book, please visit the Search
Press website for details of suppliers: www.searchpress.com

Alternatively, you can write to the Publishers at the address
above for a current list of stockists which includes firms who
operate a mail-order service, or you can write to Winsor &
Newton requesting a list of distributers.

Winsor & Newton, UK Marketing
Whitefriars Avenue, Harrow, Middlesex HA3 5RH

Publishers' note
All the step-by-step photographs in this book feature
the author, Barry Herniman, demonstrating his
painting techniques. No models have been used.

There are references to animal hair brushes in this book.
It is the publishers' custom to recommend synthetic
materials as substitutes for animal products wherever
possible. There is now a large range of brushes available
made from artificial fibres, and they are satisfactory
substitutes for those made from natural fibres.

A special thanks to Roz, John and the rest of the team at
Search Press who helped make producing this book a very
enjoyable experience.

Page 1
Maple Hill Drive, Vermont
Size: 510 x 315mm (20 x 12¼in)
*This lovely backcountry lane has some of the oldest maples in
Vermont and what a delight they are. I spent a whole day painting
in this area with the fall colours everywhere – magic!*

Page 2-3
Strong Light over Muckish, from Garniamor, Donegal
Size: 520 x 355mm (20½ x 14in)
*A winter's day walk to the top of Garniamor yielded this
magnificent view across the bay to Muckish. The clouds were
pulling back and shafts of sunlight lit up the water; one of my
favourite subjects.*

Opposite
Midday Shadows, Minori
Size: 305 x 220mm (12 x 8½in)
*A quick painting, on site, to catch the strong light on the sides of
these coloured houses. The light on the Amalfi coast is strong and
vibrant; you really have no choice other than to paint it!*

Contents

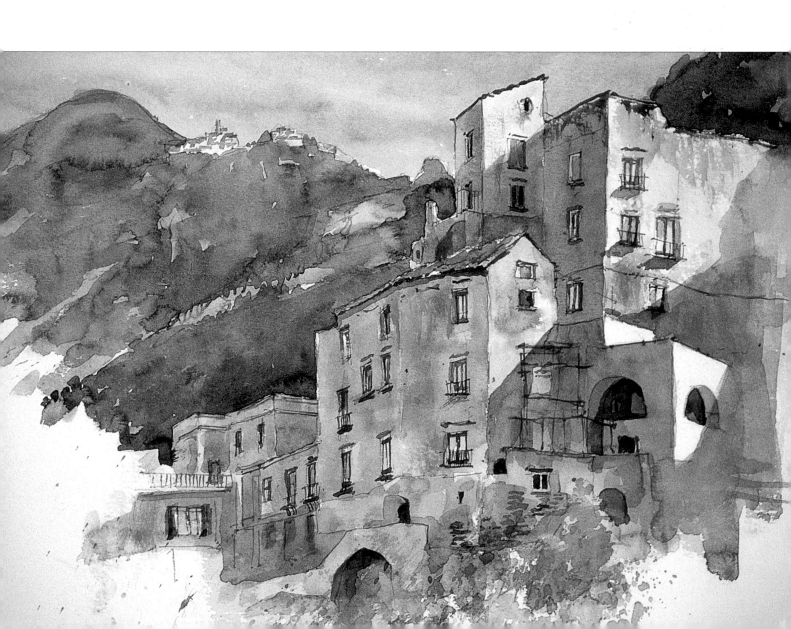

Introduction

When I first started painting, my intention was to produce a worthwhile facsimile of the scene in front of me. Basically, this was fine, and I learnt a lot of my painting craft that way. As time went on, however, I became less enamoured with creating just 'straight' paintings, and I started to explore other ways of putting paint on to paper.

What I really wanted to do was to capture the essence of a scene, 'the sense of place', and to inject the subject with that extra something . . . mood and atmosphere! Mood comes in many shapes and forms, and is open to individual interpretation. Each of us has our own perfect time of day, a favourite season or certain weather conditions that set our senses alight. When these elements prevail, that is the time to get painting.

Every landscape is dependent on light. Whether it is diffused through a soft hazy morning mist or coloured with the intense glow of a hard-edged sunset, light is the main governing factor. How often have you passed by a scene that is totally familiar to you, then, one day, the light changes or some unusual weather sets in and wham! the ordinary becomes the extraordinary?

To me, that is what painting is all about, and I call it 'art from the heart'. Before I start to paint, I ask myself what it was that grabbed my attention and made me look twice. When I have answered that question it is then a matter of deciding how to capture it.

When it comes to painting, try not to be too literal with the colours, but rather use mixes that respond to your feelings. Too much time and energy can be used mixing *just* the right green only to be disappointed with the rather static result that the colour mix produces.

Let the watercolour have its head and allow it to move about of its own accord. This can be quite scary, but I am sure you will be surprised at some of the results.

This is what I am endeavouring to impart to you with the projects in this book – to move away from just realism, and inject your paintings with mood and atmosphere.

So, good luck, and get moody!

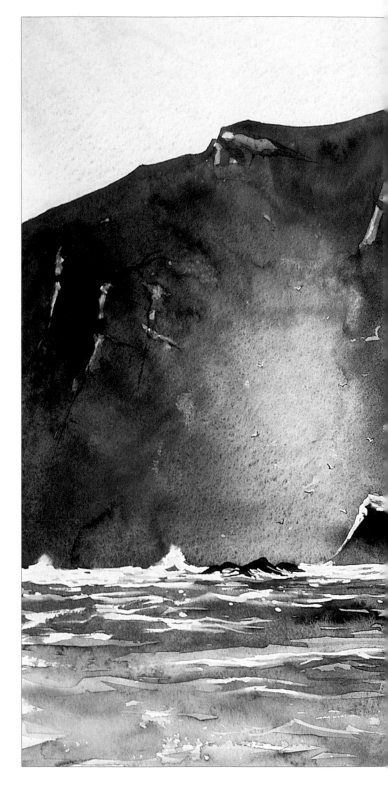

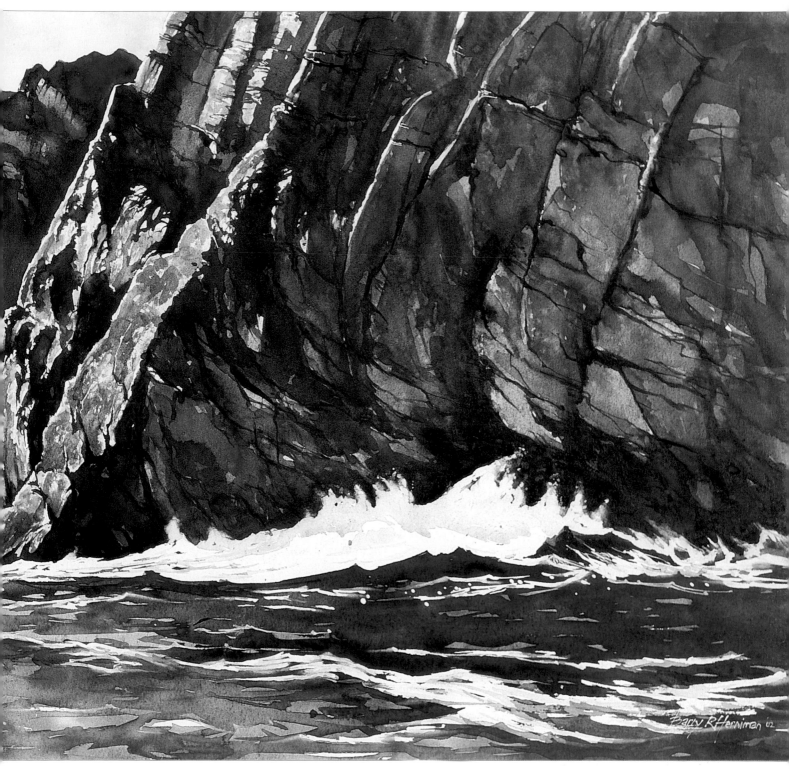

Wheeling in the Mist, Horn Head, Donegal

Size: 680 x 420mm (26¾ x 16½in)

You really cannot get moodier than Horn Head, a great slab of rock on the northern tip of Donegal. I have witnessed the peninsular in all weathers, but on this day I hired a boat to take me to the foot of the cliffs to get the view looking up at them.

Because we were so close to the rock face the sun was shielded behind cliff tops but it caught the leading edge of the head which counterchanged beautifully with the shadowed cliff face in the distance. Seagulls were wheeling about in the up currents of the early morning mist.

A very exhilarating day which inspired me to do a series of paintings of this wild Irish coast.

Materials

In today's painting world there is a whole host of materials to suit all tastes and pockets. This can become a problem in itself: because choices are so great it can be a nightmare to sort out which materials are right for you. For this reason art shows and fairs are a great place to talk to manufacturers and try out the materials before you shell out your hard earned cash; 'try before you buy' is a good policy to adopt! Also keep your equipment to a minimum, buy less but buy the best.

PAINTS

It is paint that brings light and life to a picture and the colours I use have changed over the years as I am always striving to get transparency into my work. With this in mind, I always use artist's quality watercolours which have the purest pigments available. I have tended to shy away from the earth colours – raw sienna, yellow ochre and the browns – as they are slightly opaque. I never use Payne's gray or black, and sepia and indigo are also rather heavy, but I still love burnt sienna. Mixed with French ultramarine, burnt sienna makes a great dark.

When choosing a colour the manufacturers colour chart is a good first point of reference, but there is no substitute for getting to grips with the pigment and seeing how it works for you. Colours can also vary between different brands so, if possible, it is best to try them out first.

My palette for this book consists of rich, transparent colours as I maintain you can subdue a bright colour, but you try and get life into a dull one!

I use 15ml tubes of watercolour and squeeze the paint directly into the palette. I do not use pans as I never seem to get the same richness of paint as I do with freshly squeezed paint.

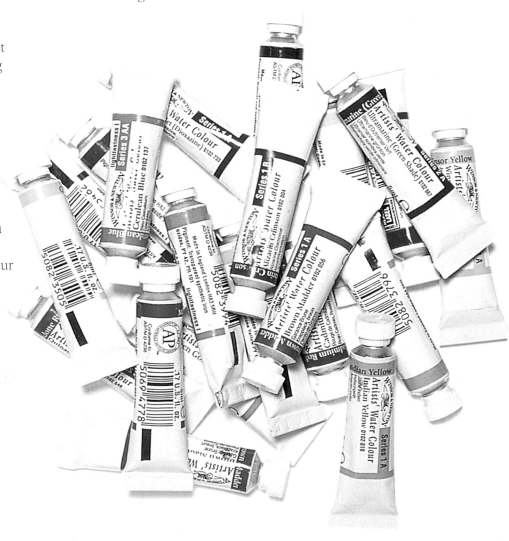

PALETTES

When working in the studio I use a variety of different palettes. My favourite is my trusty Robert E. Wood palette which my good friend, Bob Blakely, sent me from the USA. It has deep paint wells and a large mixing area with a central dam. When painting large washes, I like to use ceramic palettes with deep wells to hold lots of pigment.

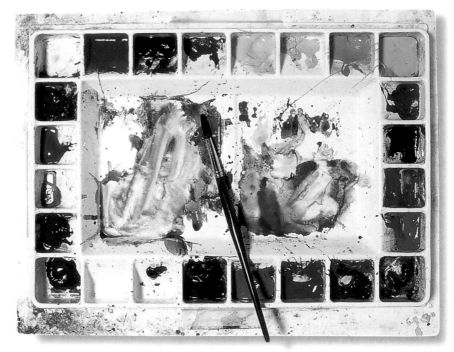

TIP NEW PLASTIC PALETTES

Paint tends to 'bead' when you mix it on a new plastic palette due to the very smooth surface. Gently rubbing household liquid scourer on the mixing areas will remove the surface shine and allow your mixes to hold together.

BRUSHES

Kolinsky sable brushes are a joy to use but I find I wear down the points rather quickly (especially the way I paint!) and once you lose the point, the brush loses its appeal. The price of some of these brushes can be astronomical but there are some super sable/synthetic brands on the market which are exceptionally good – and at a fraction of the cost of sable brushes. Not only do these have the good colour carrying capacity of pure sable brushes, they also have the durability of the synthetic materials.

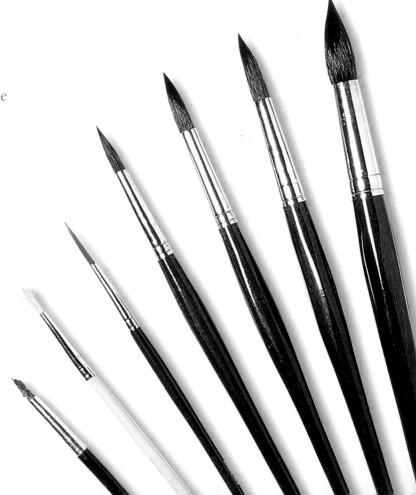

The brushes used for the projects in this book, from right to left: Nos. 16, 12, 10, 8 rounds; No. 3 rigger; hoghair brush for lifting out; and my well-worn sable (I use that term very loosely!) for applying masking fluid.

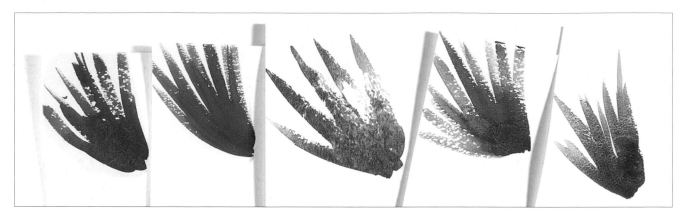

I find it useful to obtain swatches of different types of watercolour paper and see how my brush strokes work on each surface texture.

PAPERS

There are some super papers on the market and most are at very affordable prices. I have always tended to paint on 300gsm (140lb) paper, stretching it before use. But now I am using 640gsm (300lb) more often; with certain brands I can tape a piece of paper straight on to a board and start painting without stretching. Heavy papers are great for painting outdoors and for demonstrations as they do not buckle and bend as do the lighter weights. However, they do bow slightly under the weight of my washes!

Papers come with three main surfaces: Hot Pressed (HP) is very smooth and is ideal for high detail and fine line work; NOT (not hot pressed) or cold pressed paper has a semi-rough surface and is a great all rounder; and Rough which has a very pronounced surface or 'tooth', that is superb for textures and dry brushing.

Another surface I particularly like is Torchon; this has a dimpled rather than a rough surface and is very good for large wet washes.

TIP PLASTIC LAMINATE BOARD

This type of board is useful, but not for stretching paper. It has no grip for the tape and, more often than not, the tape will lift off as the paper dries. Overcome this problem by roughly brushing varnish over the surface to create a tooth.

BOARDS

My boards are made from 25mm (1in) thick marine plywood which I find stronger and lighter than MDF (medium density fibreboard). I coat them with clear varnish to seal the surface, leaving the brushstrokes to create a 'tooth' for the tape to adhere to when I stretch lighter weight papers.

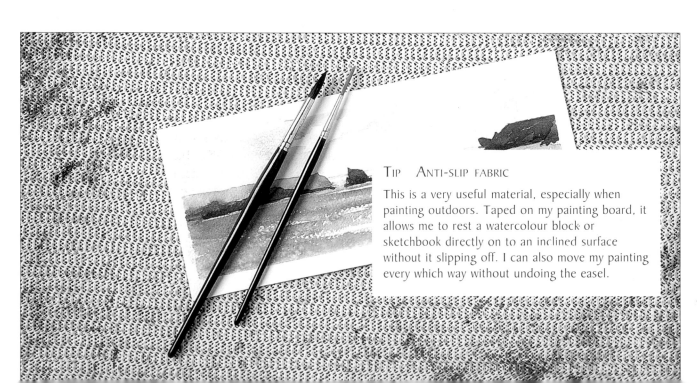

TIP ANTI-SLIP FABRIC

This is a very useful material, especially when painting outdoors. Taped on my painting board, it allows me to rest a watercolour block or sketchbook directly on to an inclined surface without it slipping off. I can also move my painting every which way without undoing the easel.

OTHER EQUIPMENT

The other equipment in my work box includes the following items:

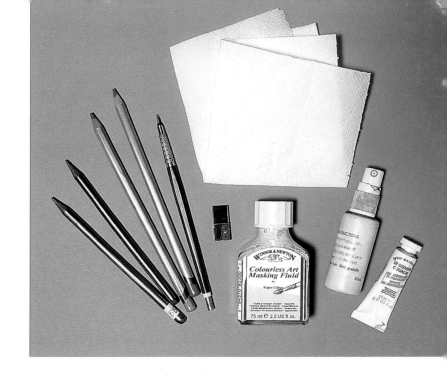

Graphite sticks (grade 2B to 8B)
I use these for drawing quick tonal sketches with plenty of oomph! (A technical word!)

Water-soluble coloured pencils
A recent addition to my work box which I find really useful for quick, on-the-spot sketching.

Clutch pencil (2B lead)
This goes everywhere with me. I am rather heavy handed when sketching and tend to break leads quite frequently, so I also have a **small lead sharpener** which enables me to keep a sharp point with minimum fuss.

Masking fluid
This is very useful if used judiciously. (Some students apply it with all the finesse of a sledge hammer.)

Spray diffuser bottle
I really would be lost without my 'squirt bottle'. Not only does it keep my paints nice and moist, but I use it to move paint around on the paper to create all sorts of effects.

Gouache (or opaque white)
This is great for ticking in those final details that add sparkle to the finished painting.

Paper towel (or paper tissues)
I use this for lifting out and general purpose cleaning. Take care though, some modern tissues are impregnated with lotions which, although good for the skin, make the paper greasy and unworkable.

Craft knife
A good tool for scraping out colour and general purpose use, but do not carry it in your hand luggage when flying!

Sketchbooks
I keep a journal of my travels in hardbound sketchbooks filled with rough watercolour paper. I paint *en plein air*, with the emphasis on speed and vitality, rather than technical expertise, to record all those special places I visit. It is quick and immediate, and I really get a lot of pleasure from sketching them. When I want to capture a wide view, I often paint right across the spine.

Watercolour field box
My field box, which is shown in the photograph (left), was handmade in brass by Craig Young and it goes everywhere with me. It folds down quite small, but there are good-sized compartments for me to squeeze my paints into. What I really love about it are the deep mixing wells in the lids which, for me, are invaluable. I have just ordered a six-well version and I cannot wait for it to arrive!

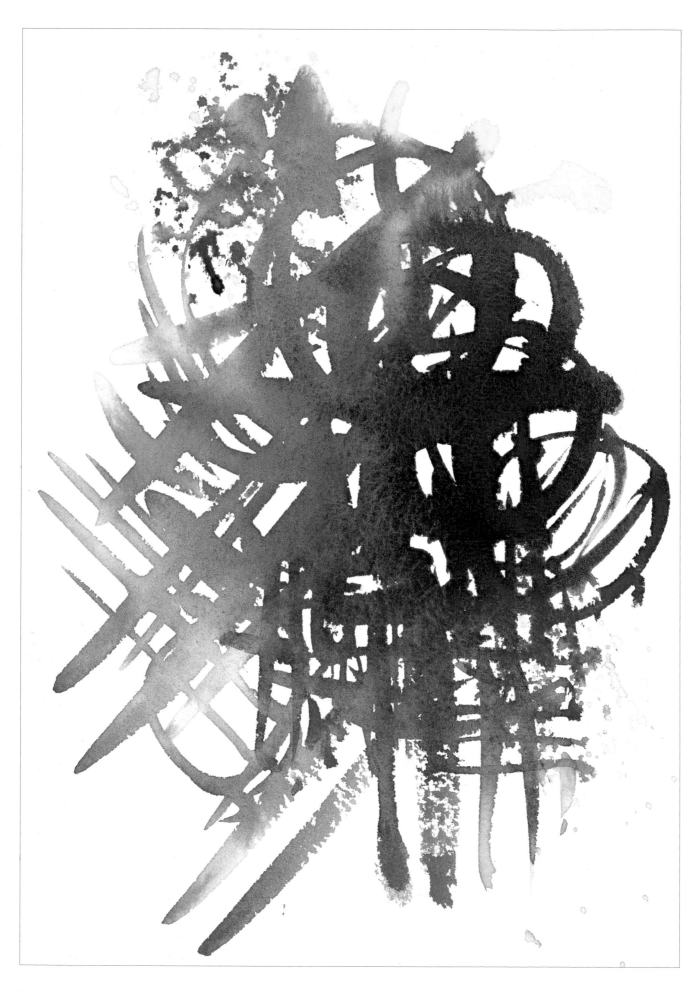

Colour mixing

At a quick glance, and before you read on, how many colours do you think went into the doodle opposite – six, eight, ten maybe? Well, there were just three! A blue (French ultramarine), a red (alizarin crimson) and a yellow (Winsor yellow).

Doodles like this show the multitude of colour mixes and tones you can create from just a few colours. Below, I have pulled out some of the colours and hues that are mixed within this doodle to give you an idea of the combinations. Simple exercises like this enable you to get to know your colours and how they work together. This only comes with practice – so get doodling!

Try this exercise yourself. First mix three generous wells of colour into a top-of-the-milk consistency – one yellow, one red and one blue – any colours you fancy, it does not matter. Fully load a large round brush with the yellow, then, with your paper at 25° to the horizontal, make some lovely loose brush

strokes across the paper. Clean your brush and do the same with the red, taking some of the strokes across and into the yellows, then watch them start mixing on the paper. Don't go back into it with your brush or you will spoil the mixing process. Now do the same with the blue, making marks over both the yellow and the red. While the paper is still wet, tilt the painting board backwards and forwards and watch out for the 'happenings'. You will be staggered at the wonderful array of colours that appear before your eyes. This is the basis of all the colour mixing in this book, mixing loads of lovely bright transparent colours right there on the paper!

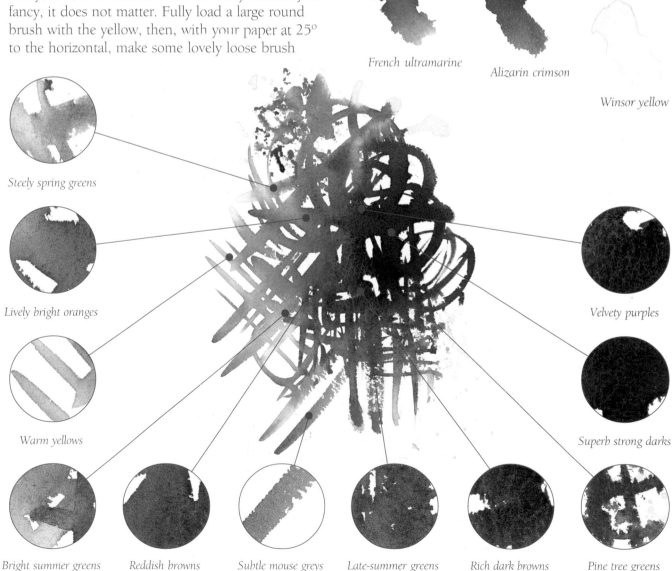

French ultramarine

Alizarin crimson

Winsor yellow

Steely spring greens

Lively bright oranges

Warm yellows

Bright summer greens

Reddish browns

Subtle mouse greys

Late-summer greens

Rich dark browns

Pine tree greens

Velvety purples

Superb strong darks

Having seen what can be achieved using the three primary colours on the previous pages, try some different combinations.

Here I have used an altogether quieter palette – aureolin, rose madder genuine and cobalt blue.

Look at the wonderfully subtle colours that can be achieved with this trio of colours. Soft but still very vibrant, there are some lovely shadow areas in there.

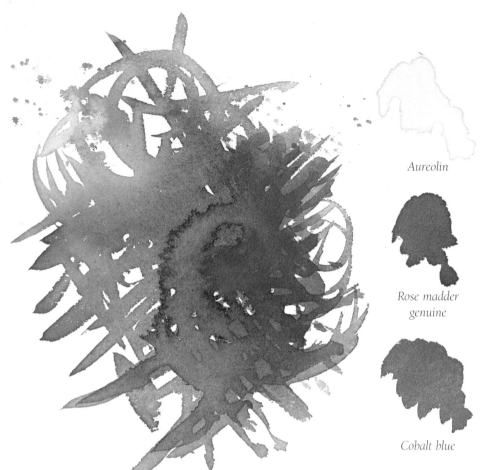

Aureolin

Rose madder genuine

Cobalt blue

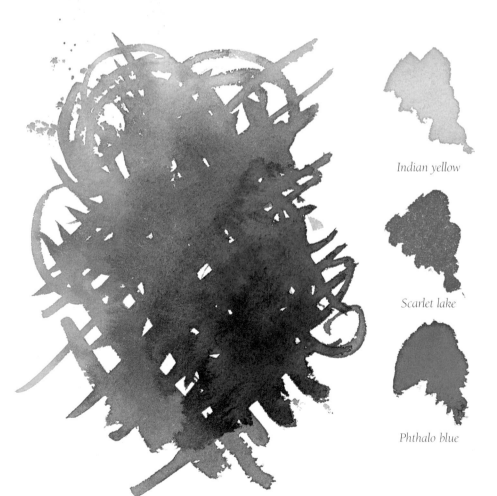

Indian yellow

If you use the trio of Indian yellow, scarlet lake and phthalo blue, you will get the much stronger mixes shown left.

Scarlet lake

Phthalo blue

14

Now if you take all nine colours – the three yellows, reds and blues – and mix and match them, just think of the endless possibilities you could get. Some of these combinations are shown below. All this with just nine colours. You may never use P.G. (you know the one!) again.

Welcome to the wonderful world of colour.

Alizarin crimson and Indian yellow

French ultramarine and alizarin crimson

Winsor yellow and cobalt blue

Aureolin and manganese blue

Phthalo blue and Indian yellow

French ultramarine and brown madder

French ultramarine and burnt sienna

I could fill a book just on colour and colour mixing, but, rather than get bogged down in a whole lot of technical jargon I want to give you a few basic tips on colours and some of my favourite mixes. Remember that nothing is set in stone and each picture should dictate the palette of colours needed to grab that particular mood.

When you first set out to buy colours, the first thing that becomes evident is that there is a staggering array of different hues across the whole spectrum. Pick up a manufacturer's colour chart and prepare to be dazzled! What I have done is to whittle down my colours to a basic minimum and add the odd exotic colour here and there when the situation calls for it.

My basic colours are cobalt blue, French ultramarine, phthalo blue, Winsor yellow, aureolin, Indian yellow, rose madder genuine, madder red dark, brown madder, also manganese blue (or cerulean blue), quinacridone gold and manganese violet.

Capturing the mood

There is mood and atmosphere all around you, even on a bright sunny day – depending where you look! This was the case with this rather tranquil scene at Faversham in Kent. I went to the boatyard and there were a multitude of wonderful subjects all in the glare of the afternoon sun. Boats, buildings and water all in sharp relief and all very colourful. When I looked over my shoulder, however, the scene changed dramatically; I was now looking into the sun, *contra jour*, and all those bright colours were severely muted, but there were some beautifully highlit shapes counterchanged against some velvety details. Painting a scene *contra jour* bleaches out a lot of the colour, but it does produce a moody scene where shapes and shadows merge together.

I took some reference photographs, but, mindful of the fact that I had to wait to see the results, I set about doing a quick tonal sketch to work out the main lights and darks and the mid tones. I then painted the loose colour sketch (opposite) *in situ* as a demonstration of how to paint highlights without using masking fluid.

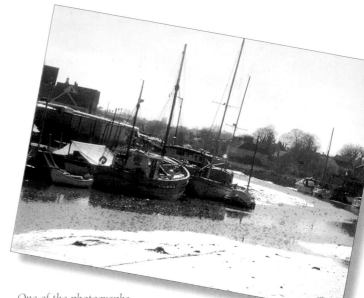

One of the photographs taken on my visit to the boatyard at Faversham. Beware when taking any photographs into the sun as the lights go white and the shadow areas go black.

This tonal sketch was worked up using a 4B water-soluble lead pencil.

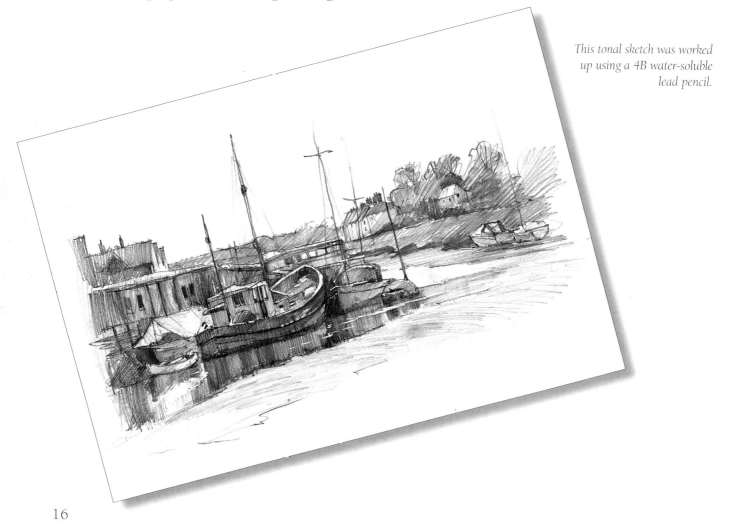

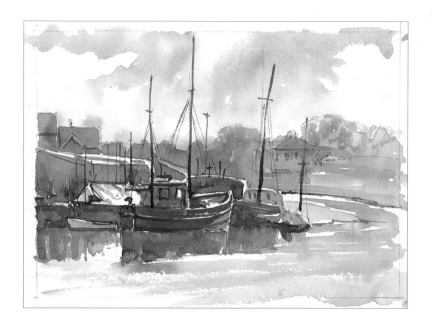

Quick colour sketch

This quick sketch demonstrates how you can paint a scene directly, without using masking fluid. I just painted around all the highlights as I worked down from the sky. It is very rough and ready, but I think it gets across the prevailing mood of the scene, and it also loosened me up to do the finished painting.

Moored up for the Day – Faversham, Kent

Size: 460 x 340mm (18 x 13½in)

This small watercolour, built up with a series of wet overall washes, was painted when I got back to my studio. The highlights were masked out so I did not have to worry about reserving them and I could concentrate on getting the washes down.

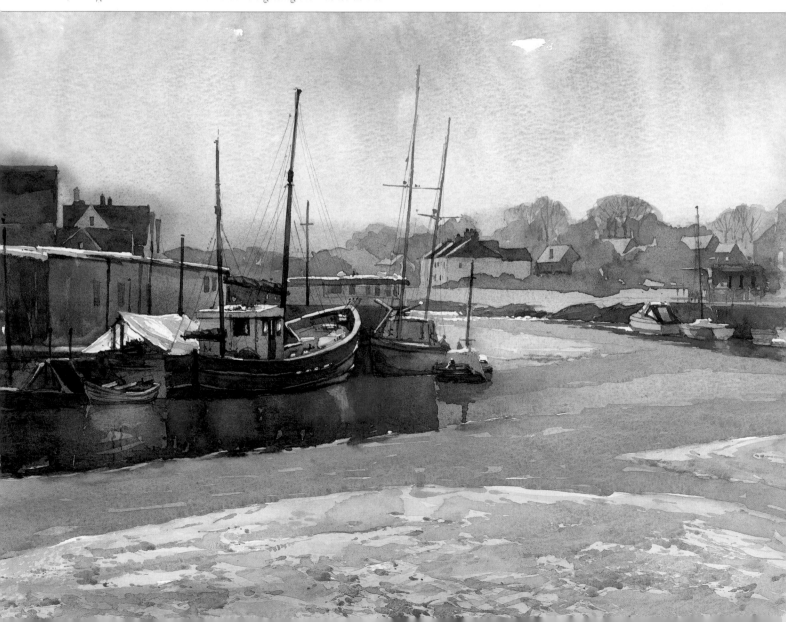

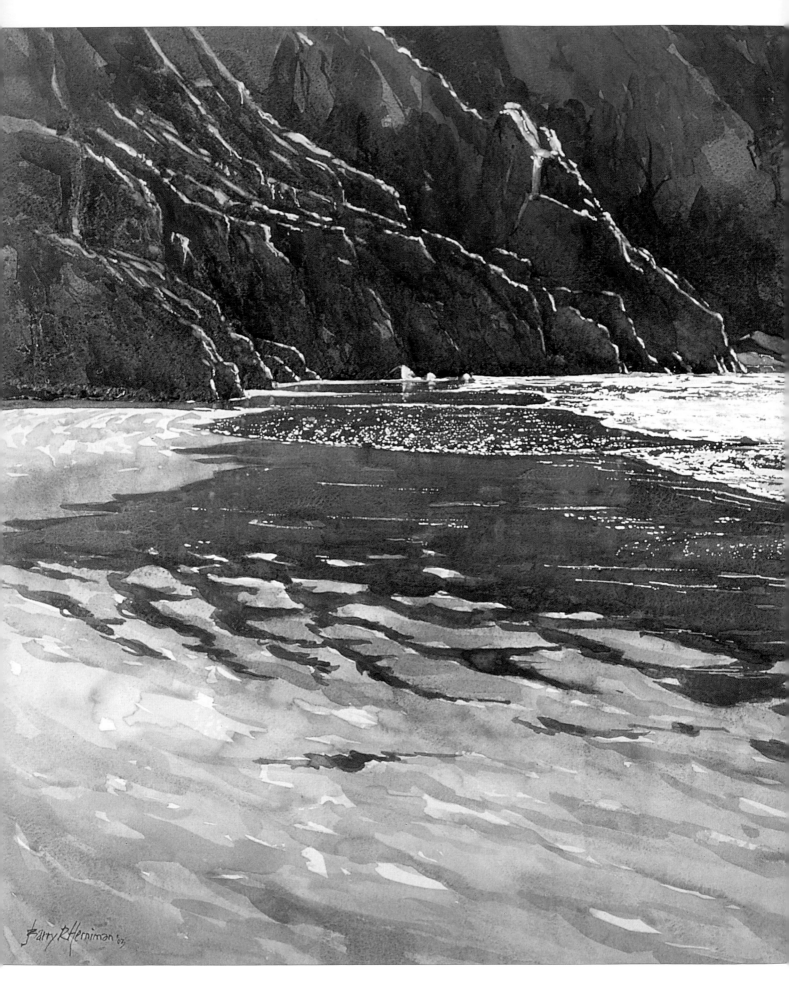

When you have found a scene that excites and inspires, all you have to do is paint it! While the adrenaline is running, I sometimes dash off a quick watercolour painting just to see how it works and comes together. Here are two versions of the same scene, one painted on site, the other worked up in my studio.

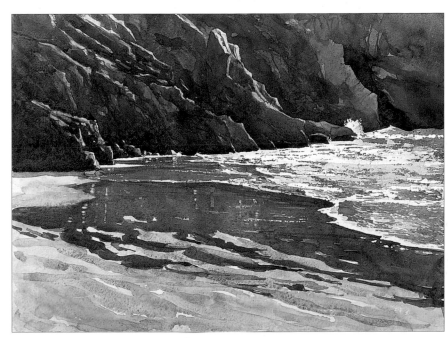

Receding Tide, St Catherine's Rocks

Size: 400 x 300mm (15¾ x 11¾in)

This painting was quite small, but I had a great time getting all the rock colours moving and mingling together, and highlighting their edges to give them a little lift.

I experimented with masking fluid for the highlights in the water to get the sparkling effect and built up the colour densities of the sea with a succession of transparent glazes.

Receding Tide, St Catherine's Rocks

Size: 775 x 660mm (30½ x 26in)

Having completed the small painting above, I was all fired up to paint this much larger version – with a few modifications. I was happy with the colour combinations in the rocks and the sea, but the overall format was not what I wanted. I felt that a larger expanse of foreground beach would give the scene a greater air of solitude. Having worked up various pencil compositions, I decided on this almost-square format. It has a good amount of wet and dry sand in the foreground that helps lead the eye into the painting, and this also acts as a foil to the darkness of the sea and rocks.

MAGIC OF THE MOMENT

It is not always possible to sit and paint a scene that really grabs you, but, when you can, it is a bonus. I was very lucky with this scene of the Roman Bridge at Penmachno, North Wales. While giving a painting demonstration one morning, I was able to get the magic of the moment down on paper. In this very quick, direct painting, I was intent on capturing certain light qualities rather than concentrating on detail. The morning sun was just clipping the fringe of yellowish grasses on top of the bridge, and the strong silvery light on the water brought the underside of the bridge into sharp relief.

It was quite a magical moment!

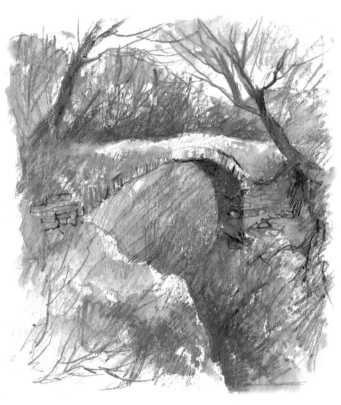

Back in my studio I played around with water-soluble coloured pencils, simplifying some of the elements and emphasising others to give a more dramatic slant to the scene.

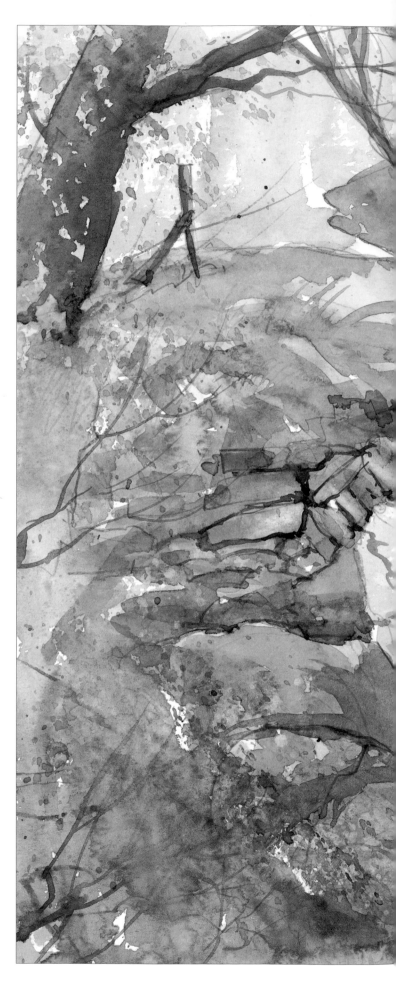

Catching the Light
Size: 430 x 330mm (17 x 13in)

20

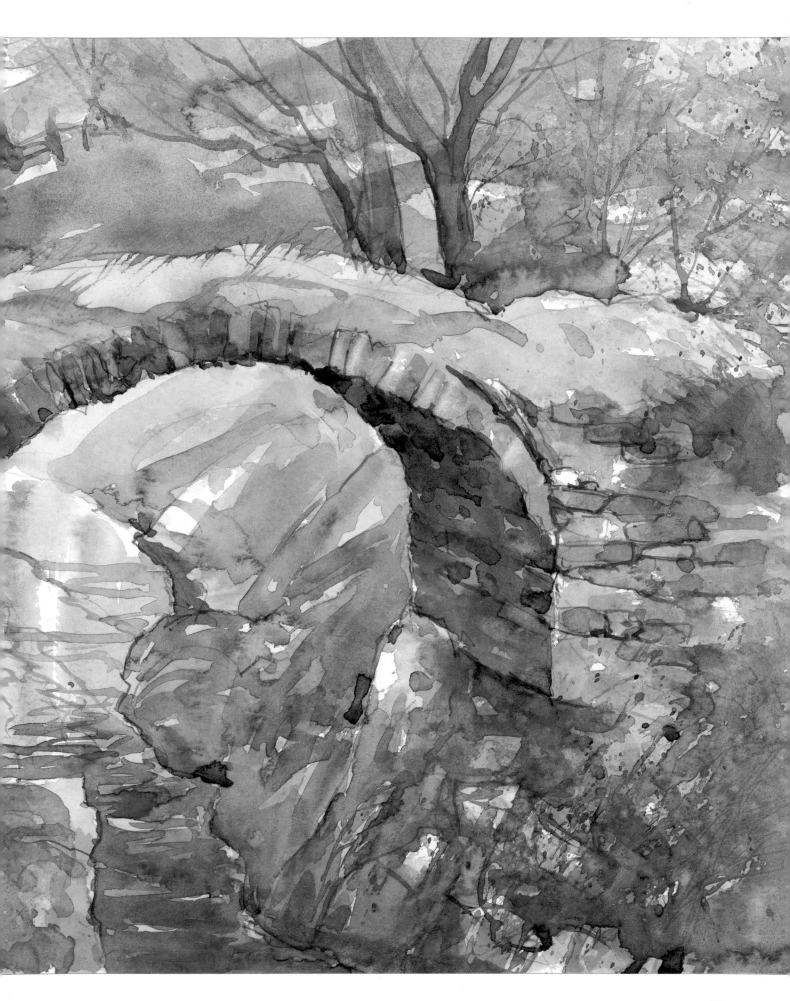

Techniques

There are many diverse and wonderful methods of making marks on paper and I am always experimenting with different ways of creating textures and patterns that will enhance a painting. However, do not let techniques take over! Techniques for techniques' sake will make a painting contrived and overdone, and the question asked will be, 'how did you do it', rather than 'why did you do it'. Techniques should only be used to enhance a painting and produce textures that cannot be accomplished by regular painting methods.

TIP REMOVE MASKING FLUID AS SOON AS POSSIBLE

Be careful not to leave masking fluid on the painting too long. Get your initial washes down, then, as soon as they are dry, get the masking fluid off.

Masking fluid applied with an old brush.

MASKING FLUID

This is a really great medium which enables you to do a wet into wet wash over the whole painting and still reserve your whites. But beware! If masking fluid is applied with a heavy hand – slopped on as if with a plasterer's trowel or squeezed out like toothpaste from a masking fluid pen – you could end up with something rather horrid. I apply masking fluid with an old brush, a twig, a piece of string or anything else that makes a delicate painterly mark and the result is better for it.

TIP MASKING FLUID AND HAIRDRYERS

Take care when using a hairdryer to dry paintings with masking fluid on. The heat can make the masking fluid rubbery, causing it to smear when you try to remove it.

Masking fluid spattered on to the paper, then moved around with the handle of a brush.

Highlights scraped out of dry paint with a scalpel.

SCRATCHING OUT ON DRY PAINT

Use quick sideways movements of a craft knife to carefully scratch highlights out of dry paint. A great technique for those final sparkles across water. But, it does damage the surface of the paper and you will not be able to paint over it once done.

Scraping out from wet paint

This is a great way to produce light tree trunks against dark backgrounds. The underlying paint must be just damp for this to work. Lightly scrape the side of a palette knife, finger nail or credit card (nothing with too sharp an edge) into the paint to produce your light marks. If the paint is still too wet the mark that is left will be considerably darker – which is fine if you planned it that way!

Tree trunks scraped out of wet paint with the handle of a brush.

Lifting out

You must let the paint dry for this technique to work, and you should use a brush that is slightly more abrasive than a watercolour brush (a hog or bristle brush is ideal). Wet the brush with clean water, gently rub the area to be lifted, then dab the wet marks with a clean piece of paper towel to lift the colour.

Highlights lifted out with a damp brush.

Dry paint spatter lift

Another way of lifting out paint is to use the spatter technique. Flick a brush, loaded with clean water over a dry passage of colour, leave for a while, then dab the wet marks with a clean paper towel. Alternatively, use a squirt bottle to apply a light spray of clean water over an area and lift out with a paper towel. These methods of lifting out create a really good random texture which is great for rocks and cliffs.

These marks were made by lifting out colour after flicking a brush loaded with clean water on the dry paint.

Here I used my squirt bottle to spray water on the dry paint before lifting out the colour.

BACKRUNS

The last thing you want in the middle of your lovely sky wash is a backrun or 'cauliflower'. But, in certain areas, you can use backruns to great effect. Leave the wash until it starts to dry, then touch a brush loaded with colour on the spot where you want the backrun and see what happens. This is a rather unpredictable technique, so use it with care.

Backruns can be used to great effect.

DRY BRUSH

This technique works best on a rough paper that has plenty of tooth; it is perfect for speckled highlights on water. Load a brush with colour (not too wet, or it will flood into in the 'valleys' of the paper and you will lose the sparkle), then drag the side of the brush quickly across the paper catching the 'ridges' of the paper surface.

Speckled highlights created by dragging a dry brush (loaded with blue paint) across the surface of rough paper.

SALT

Using salt is lovely way to create texture, especially within foliage areas. Allow the wash to dry slightly, then drop in dry salt crystals where you want the texture to be. The pattern that emerges is completely unpredictable, as it is dependent on the dampness of the paper and the size of the salt crystals.

Salt applied to wet paint creates a random patterned effect.

GOUACHE (OPAQUE WHITE)

Gouache is a good way of producing small, crisp, wispy highlights. Here, I used gouache to brush in some water rivulets over the rocks, then flicked on more paint to form the spray. Do not overdo the use of gouache; remember that it is opaque and you can very easily create a very dull passage of colour.

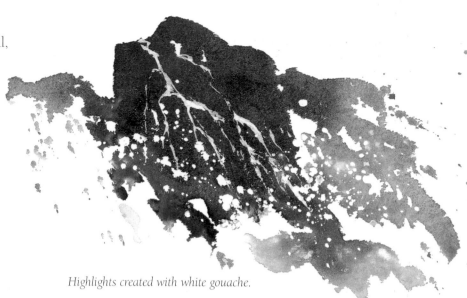

Highlights created with white gouache.

TIP USING GOUACHE

Unlike watercolours which tend to dry lighter than the applied wet colour, gouache dries darker – and the more you dilute it the darker it becomes. If you want a really white highlight, you will have to use almost neat white gouache.

Two colours spattered together on dry paper (left) and wet paper (right).

SPATTERING

This technique can be done in any number of ways and combinations. In this example, I loaded a brush with yellow paint, then flicked the point diagonally across the paper. While that was wet I introduced some blue. Half the paper was dry and the other half had water on it – notice how the paint diffused nicely on the wet side.

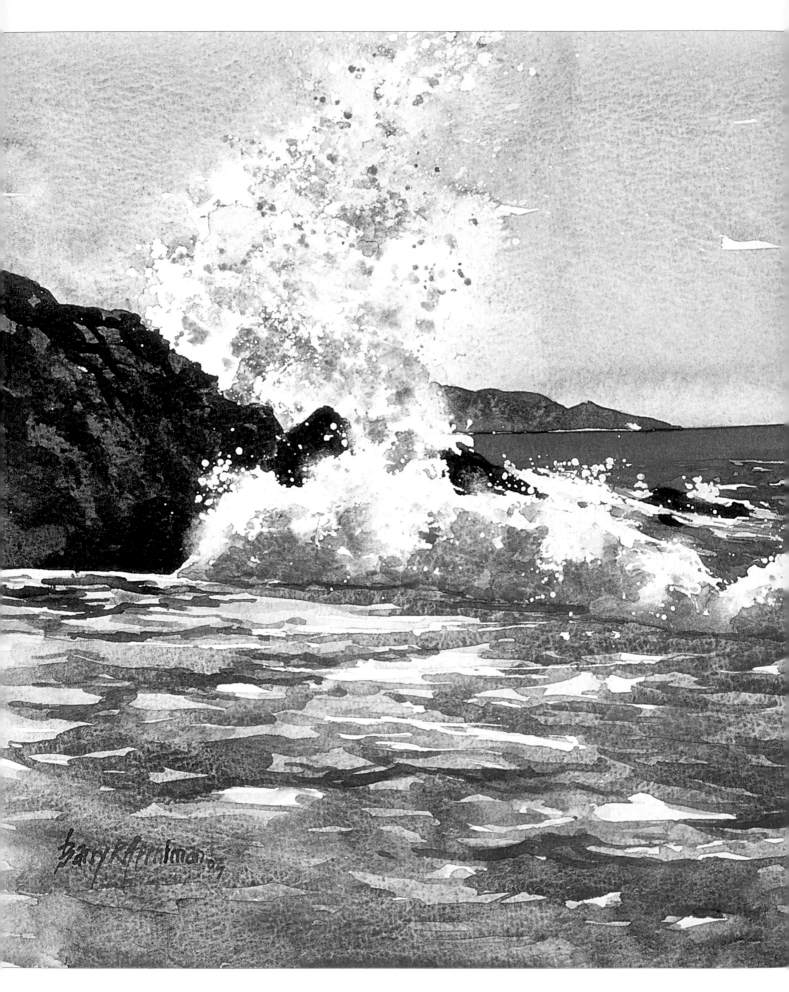

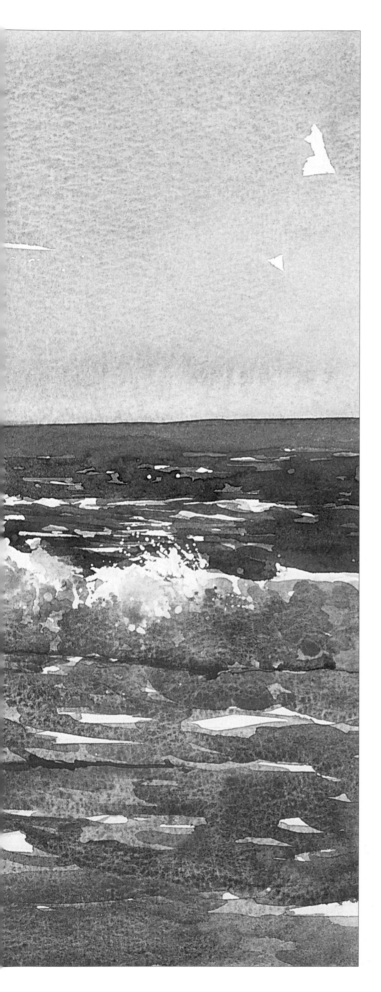

Breaking waves

I love the sea and all its moods, so I just had to start the step-by-step demonstrations with a seascape. I have such an affinity with water whether it is the sea, rivers, streams, lakes or ponds, that I feel that I should have been born under Aquarius. Water, in some form or other, seems to find its way into most of my paintings, even if it is only a puddle! I can spend hours just looking at the sea, watching the patterns that emerge, then disappear; all quite mesmerising. Because of the fluidity of water I am able to give vent to my artistic temperament. I am not restrained by architectural detail and I can 'splash' around quite freely.

What I wanted to convey here was the simplicity of a scene with a rather dramatic, crashing wave. On this particular morning the wind was quite strong and, although the sea was not overly rough, it created a deep swell and some hefty breakers on the rocks. This gave me the chance to lay in some gentle, gradated washes for the sky and some loose, flowing ones for the sea.

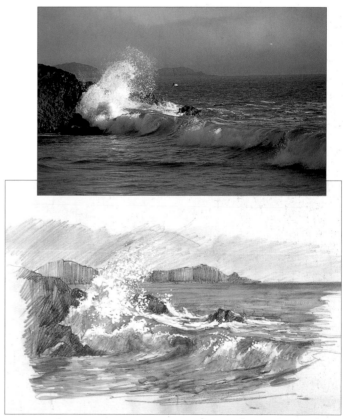

The photograph and tonal sketch above were used as the reference material for the demonstration. Quick tonal sketches (this was worked upon cream paper using water-soluble pencils) are useful for defining the lights, darks and mid tones in the composition.

27

1 Use the reference material to draw the outlines of the composition on to the watercolour paper. Do not make the pencil marks too faint, or you will not be able to see them when the first washes have been applied.

2 Use masking fluid and an old brush to spatter highlights in the spray from the wave crashing against the rocks. Work carefully, changing the angle of the brush with the direction of the spray . . .

3 . . . then use the handle of the brush to blend some of the spatters together to form nearly solid areas.

The paper with all the masking fluid applied.

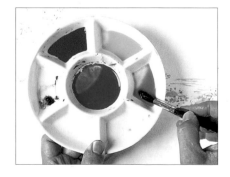

4 Using a palette with large deep wells, prepare the initial washes: cobalt blue, Winsor red, Indian yellow and manganese blue.

5 Spatter clean water round the big wave (to stop hard edges forming), then use the No. 16 brush to lay in a band of cobalt blue.

6 Add some Winsor red, then blend this into the blue. Spread the colours down towards the horizon, blending in touches of Indian yellow in the lower sky. Allow a bead of colour to form on the horizon line.

7 Leave the wet bead of colour to form a hard edge, then use a dry brush to remove the excess water.

8 Spatter clean water into the large spray area, then drop in touches of manganese blue, cobalt blue and Winsor red. Spatter more of the same colours to create smaller marks.

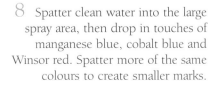

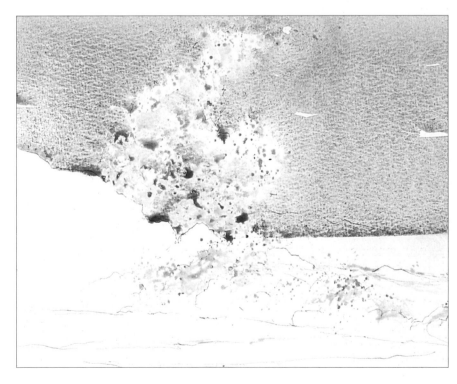

9 Add the sea colours – phthalo blue, aureolin, alizarin crimson and French ultramarine – to the palette, then work on the area of sea behind the waves, wet on dry. Lay a band of cobalt blue along horizon followed by a band of phthalo blue. Add touches of alizarin crimson and aureolin. Dipping the brush into various colours, make the brush strokes looser and the saved whites bigger as you work down the paper. Turn the painting upside down to create a strong edge on the horizon and leave to dry.

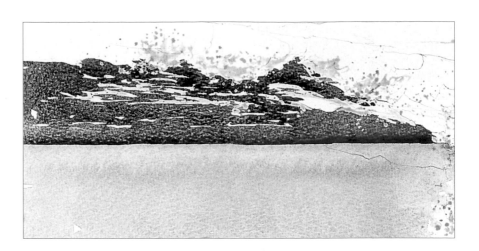

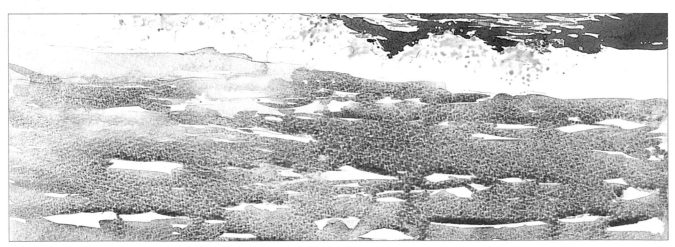

10 Use weak washes of manganese blue and alizarin crimson to lay in the pale area of sea below the large breaking wave at the left-hand side. Develop the remaining part of the foreground with loose brush strokes of cobalt blue, Indian yellow, alizarin crimson and aureolin. Push, press and pull the brush on each stroke to create the small wave shapes. Again, make the saved whites bigger as you work down the paper.

11 Angle the painting board up at the left, then drop in more cobalt blue, Indian yellow and alizarin crimson, wet in wet, and allow these to run across the paper. Lift the other side of the board to make the colours flow back across the paper, then leave to dry with the top edge raised slightly; the hard edges that form create shadowed areas among the waves.

12 Spatter clean water over the left-hand side of the large spray area, then start painting at the left-hand side of the paper. Using rock colours – brown madder, burnt sienna and French ultramarine – block in a base coat of colour for the rocks, then drop in touches of alizarin crimson and Indian yellow here and there.

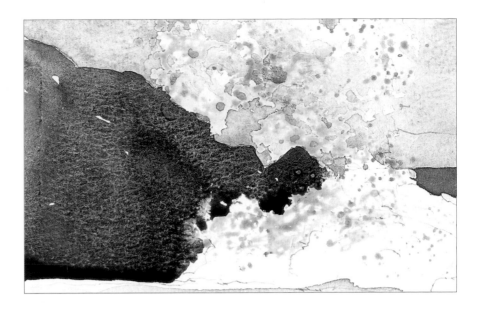

13 Use the same colours to paint the rocks at the right-hand side of the wave. (There is a lot of masking fluid in this area, so you can still use bold brush strokes.)

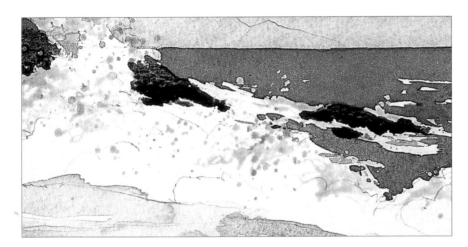

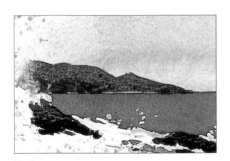

14 Wet the left-hand edge of the distant mountain, then use weak washes of the same colours with a touch of cobalt blue to paint the mountains. Leave a thin white line between the mountains and sea to suggest breaking waves.

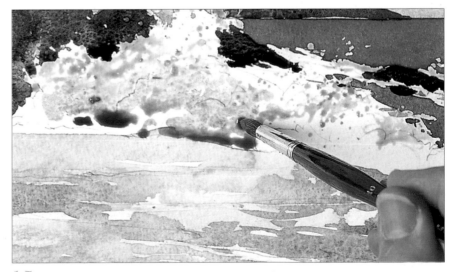

15 Now work up the shadows on the breaking waves with cobalt blue, alizarin crimson and a touch of manganese blue. Holding the brush nearly vertical, trickle the colours into the bottom area of the wave. Work the colours between each other, then allow them to blend. Allow beads to form to create sharp edges at the bottom of the wave.

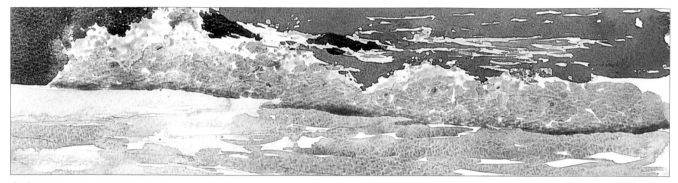

16 Continue building up the shadows across to the right-hand side. Use a dry brush to remove some of the excess wash colours from the bottom of the wave. Leave others to create hard edges. Leave to dry completely.

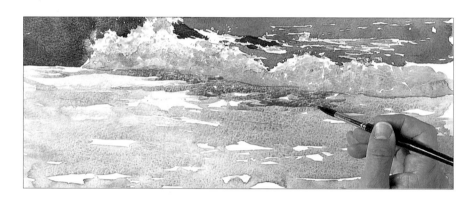

17 Dipping into the sea colours – cobalt blue, French ultramarine, manganese blue, alizarin crimson and manganese violet, and working wet on dry with a near-vertical No. 10 brush and a trickling action – start to strengthen the colours in the foreground. Vary the angle of the brush strokes to suggest movement in the water.

18 Continue building up the foreground leaving some of the saved whites from the initial layer of colour. Push, press and pull the brush to create the wavelet shapes. Apply a weaker wash over the nearest part of the foreground.

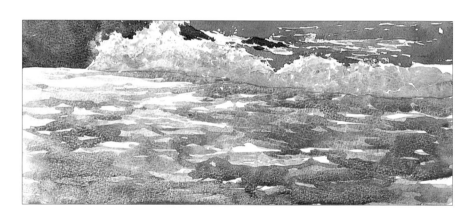

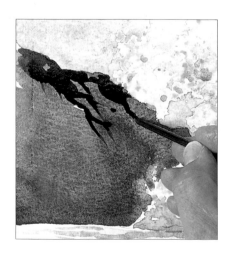

19 Dipping into the rock colours with a No. 10 brush, start adding colour along the top edge of the rocks then use the handle of the brush to pull the colour down to form fissures.

20 Create shadows on the rocks with a rigger brush. Load the brush by dipping into the rock colours, flatten it on the paper then drag it sideways and downwards across the rocks.

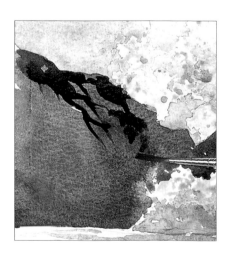

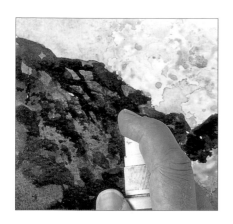

21 Spatter darks over the rocks, then spray a fine mist of water over the wet paint to soften some of the hard edges of the fissures. Leave to dry, allowing the shape and structure of the rocks to develop on their own.

22 Use weaker tones of the rock colours to develop broken reflections of the rocks in the water. Push, press and pull strokes of the rigger brush to reflect the shapes of the wavelets.

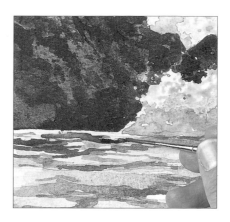

23 Working with the shapes already on the paper, use darker tones of the sea blues in the palette to accentuate them and create shadows against the highlights.

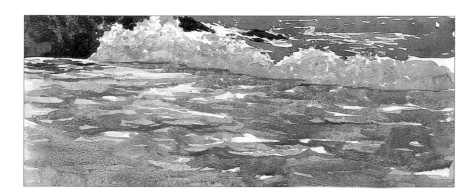

24 When the painting is completely dry, remove all masking fluid (I use an old piece of dried masking fluid as a 'lifter'). Run your fingers all over the surface to check for small areas you might have missed. We now have to go into these stark white areas and soften some of the hard edges (see steps 25–27).

33

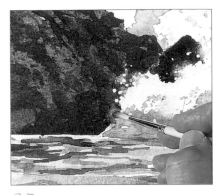

25 Now go into the exposed, stark white areas and soften some of the hard edges. Use a bristle brush to wet the edges of colour where the spray falls on the rocks . . .

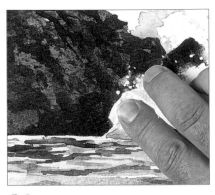

26 . . . use clean paper towel to dab the wetted area . . .

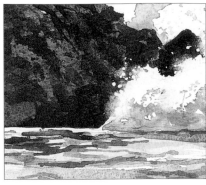

27 . . . then lift off to reveal the softened edges.

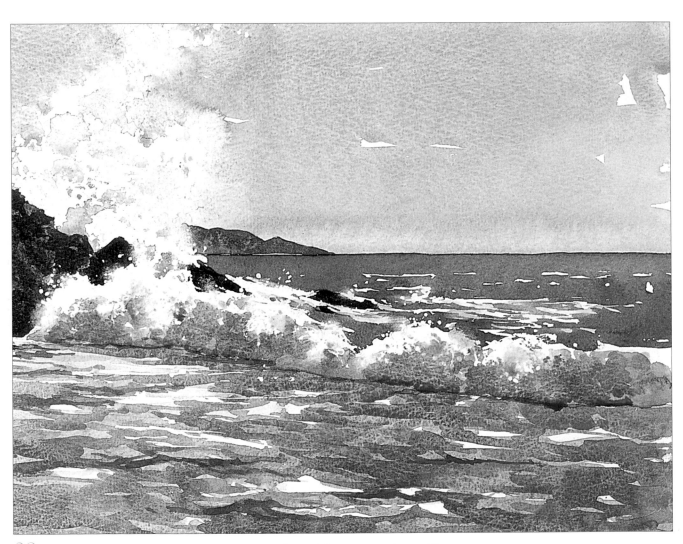

28 Work the same technique to soften the top edges of the waves in the middle distance and some of the edges of the shadows in the larger breaker and in the area of spray. Spatter water in the shadowed area of the breaker then trickle accents of darker tones of the sea blues to develop shape and form. Spatter small spots of colour into the waves, then soften all edges with clean water.

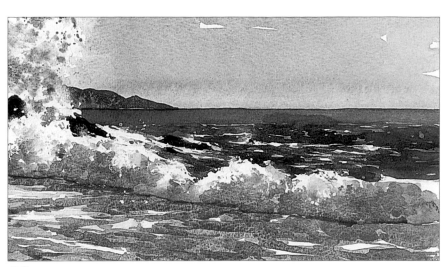

29 Develop the colours in the large spray area by spattering some darks followed by water to soften the edges.

30 Develop the middle distant area of sea with phthalo blue and touches of alizarin crimson and Indian yellow. Cover some of the saved whites but leave others. Wash a mix of these colours across the far distant sea.

31 Complete the spray area by spattering touches of white gouache over the top part of it, then develop the fine spray along the top of the breaking waves. Vary the angle of the brush as you spatter.

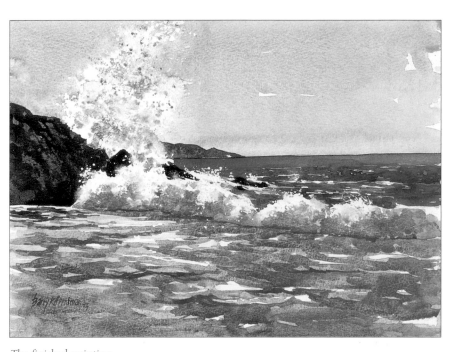

The finished painting.

TIP WHITE GOUACHE

This white will not be as bright or white as the paper but it is good to add tiny highlights.

It is, however, a very opaque white, so never put it in your palette of watercolours – even a touch of it can spoil the transparency of watercolour.

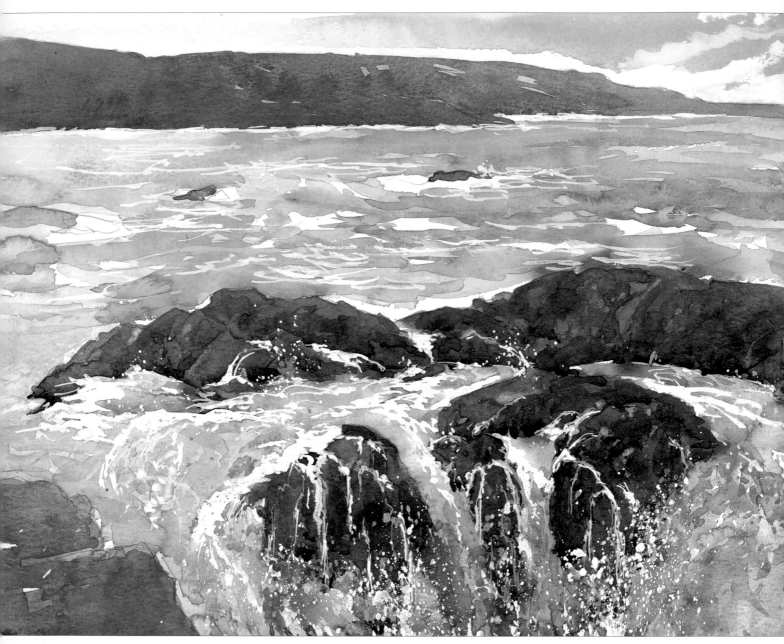

After the Wave, Donegal.

Size: 460 x 350mm (18 x 13¼in)

The sea on this day did not look overly rough but there were some deep swells, which produced some fairly spectacular spray where the sea met the rocks. I was in danger of being engulfed by a couple of them.

This was the aftermath of one such wave which left behind a welter of white foam and spray as the sea slid down between the rocks.

I did this as a demonstration and wanted to capture the chaos of the water as it bubbled over the rocks.

I masked out some areas of foam and flicked and spattered white gouache on others to get this random effect.

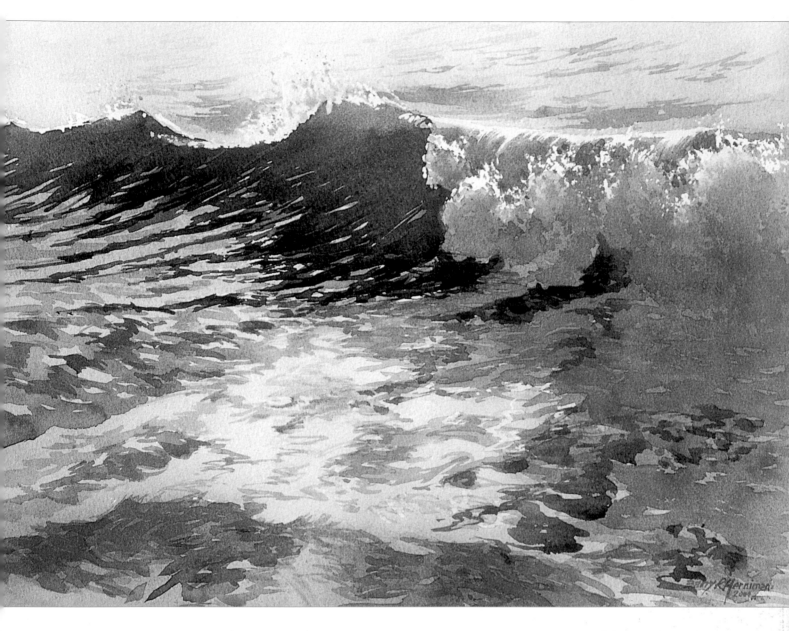

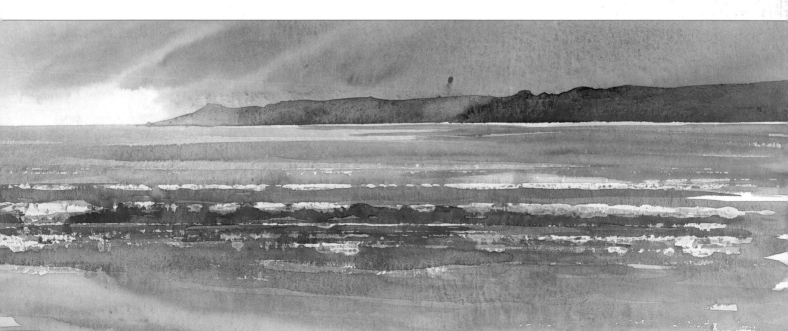

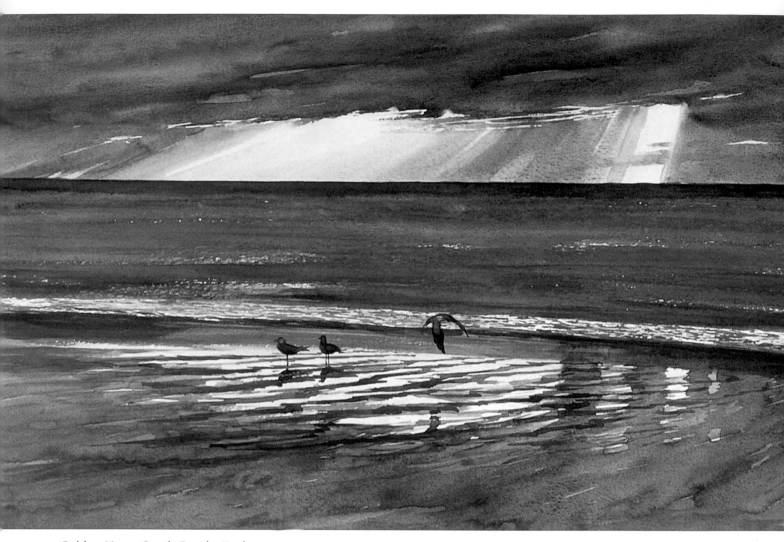

Golden Hour, South Beach, Tenby

Size: 640 x 400mm (25¼ x 15¾in)

The storm had passed over and the evening light was starting to come through the clouds at the horizon. The sea was calm and flat now, and the beach, still wet from the rain, was reflecting the bright sky.

Break in the Clouds, Tenby

Size: 460 x 320mm (18 x 12½in)

This was a moment just before the sun appeared and lit up the whole scene. There was a strong glow around the edge of the clouds suggesting that the sun was on its way.

I have accentuated the billowing action of the cloud forms to get a lot of movement into the scene.

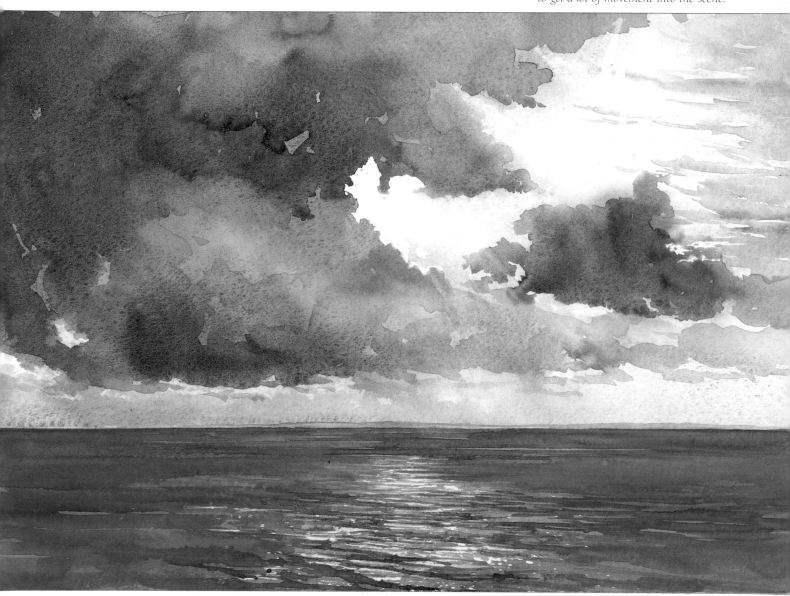

Stormy skies

Recently, I travelled up to Argyll in the west of Scotland and was greeted with some kind Scottish hospitality and some terrific Scottish scenery. Because the landscape is crisscrossed with so many lochs and valleys, the weather systems tend to move through at a considerable rate of knots. Wait five minutes and you can have a complete change of weather! All this adds up to some pretty dramatic skies and it is one such sky that I want to portray in this demonstration.

I took several photographs all of which had completely different skies. In the one used as the reference for this painting, I managed to catch the scudding clouds as they clipped the top of the mountains. The clouds were quite dark and foreboding, but they had a tremendous luminosity that made them shimmer.

The natural tendency is to make dark clouds much *too* dense and heavy, especially when working from photographs. I recommend that you try to keep your skies light and airy and very transparent, even when dealing with storm clouds. If you do not, you could end up with a rather clumsy result.

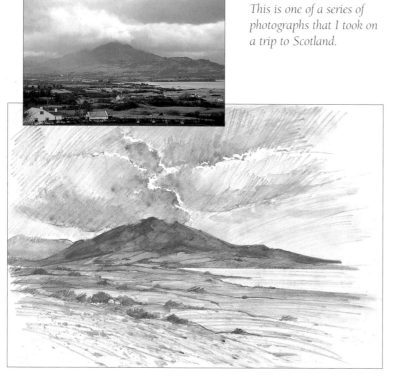

This is one of a series of photographs that I took on a trip to Scotland.

I used the photograph and water-soluble pencil sketch above as the reference material for this demonstration.

Water-soluble pencils are great for getting texture into tonal studies. Here I used them to get the tones into the sky and land, softening the hatching by rubbing the marks in the sky with my finger. I used a brush and clean water to merge the marks in the mountain area.

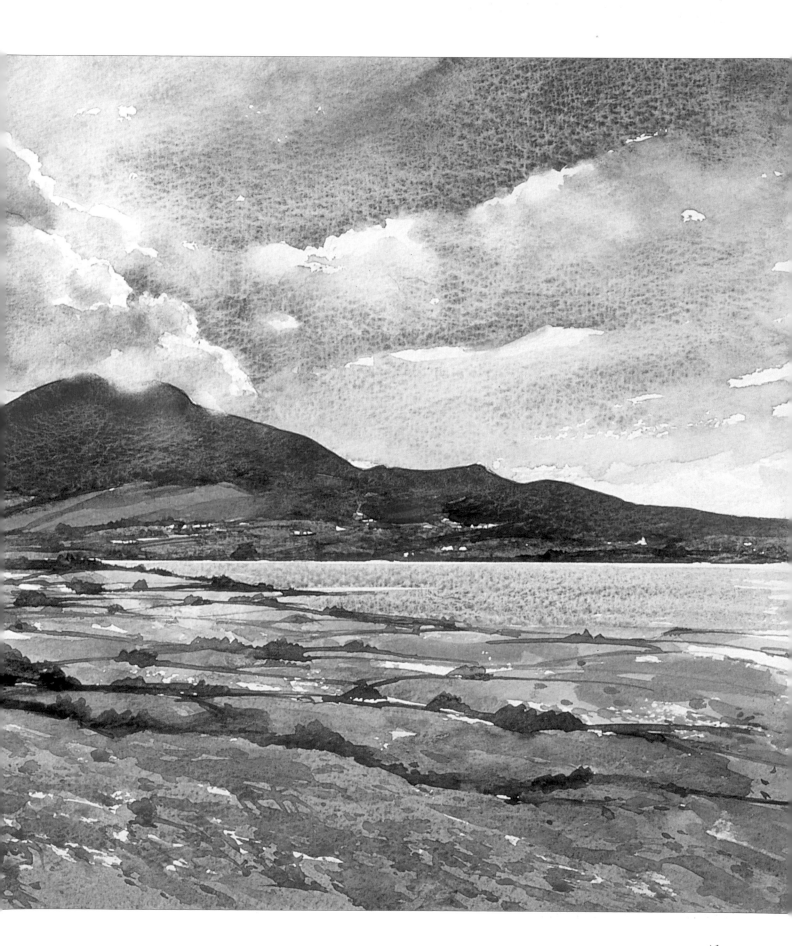

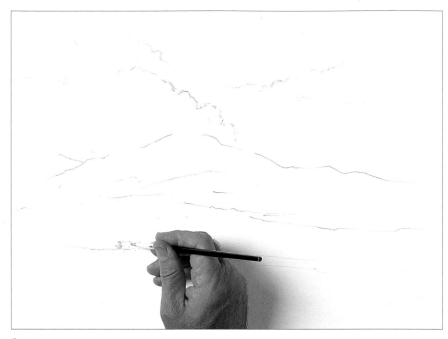

1 Sketch the basic outlines of the composition (keep it simple and only include the main elements), then use an old brush to apply masking fluid to some of the cloud edges and to the end of the small house in the middle distance.

2 Prepare the initial washes: quinacridone gold, French ultramarine, Winsor red, manganese blue, cobalt blue, rose madder and Indian yellow. Wet the top of paper, then start the sky by introducing French ultramarine, Winsor red, and cobalt blue. Push the brush into the cloud area and roll it from side to side to create texture.

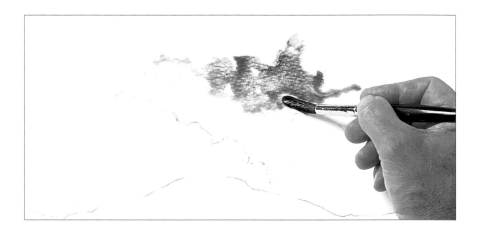

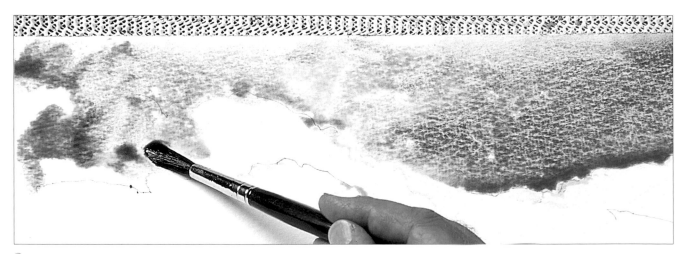

3 Pull the colours down to the top edge of the clouds. Tilt the board to allow the colours to run into each other, then introduce quinacridone gold, with touches of Indian yellow, Winsor red and cobalt blue into top left of the wet paper.

4 Work down the paper, adding more cobalt blue and Winsor red, then soften the tones beneath the clouds with rose madder genuine.

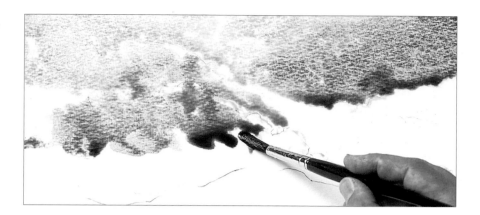

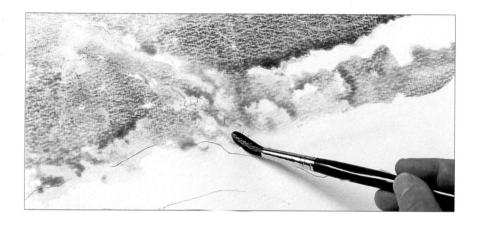

5 Pull the colours down into the mountains, diluting them slightly, then, at the right-hand side of the sky, introduce manganese blue and touches of rose madder genuine.

6 Tilting the painting board to allow the colours to flow across the paper, add weaker washes of the sky colours to the lower right-hand side of the sky, softening the bottom edges. Accentuate the billowing clouds with cobalt blue and Winsor red.

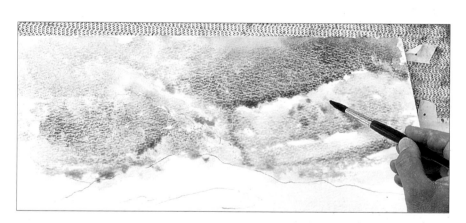

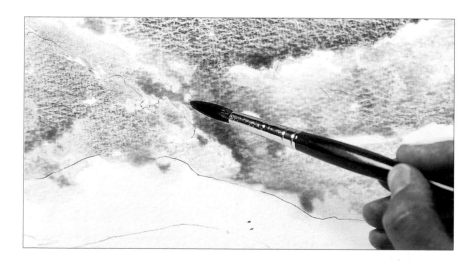

7 Add manganese blue and Winsor red to the centre sky. Touch the tip of the loaded brush on to the surface of the paper and allow the paint to run out into the wet area.

8 Strengthen the top, left-hand corner of the sky with more cobalt blue and Winsor red . . .

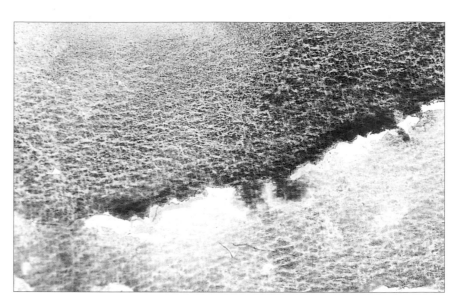

9 . . . and the top, right-hand part of the sky with French ultramarine.

10 Allow the sky colours to dry, then, referring to the tip below, apply a strip of masking tape to the top edge of the loch.

TIP MASKING TAPE

This is ideal for masking sharp-edged straight lines. If it is applied to watercolour paper straight from the reel, however, it could damage the paper when it is removed. Reduce the tackiness of masking tape by rubbing your fingers over it before you stick it to the paper.

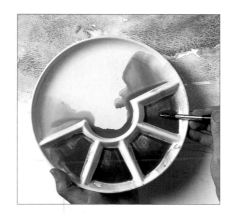

11 Prepare the washes for the landscape: Indian yellow, Winsor red, permanent magenta, French ultramarine, cobalt blue and quinacridone gold.

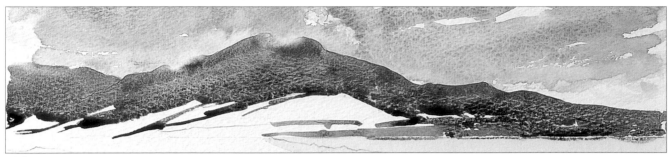

12 Referring to the diagram above, wet the edges of the mountains shown in red, then drop in the colours. Use French ultramarine, cobalt blue and permanent magenta on the highest peaks and the other mountains to the right of these, adding touches of quinacridone gold on the lower slopes. Use permanent magenta for the distant mountain at the left-hand side to reflect the pink in the sky. Bring quinacridone gold across from the right-hand side to define the far bank of the loch.

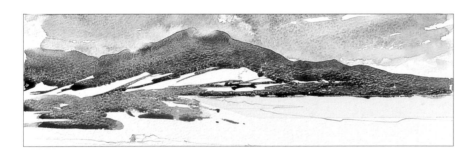

13 Lay in the middle distance area at the left-hand side with quinacridone gold and Winsor red, warming up tones as you move to the right. Use touches of cobalt blue, French ultramarine and permanent magenta to work up shape and form on the far bank of the loch.

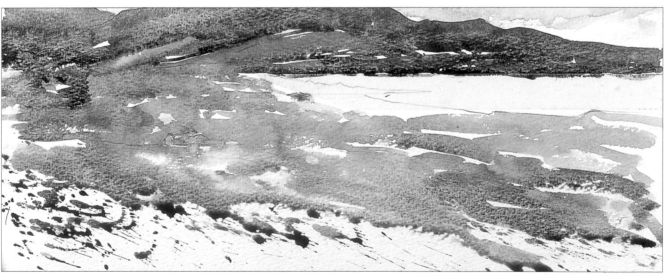

14 Dipping a No. 12 brush in quinacridone gold, Indian yellow and Winsor red, work up the lower slopes of the mountain, then work up the foreground area with the same colours, adding touches of permanent magenta and cobalt blue at the right-hand side. Raise the top, left-hand corner of the painting board, then spatter Winsor red, quinacridone gold and cobalt blue over the bottom of the paper.

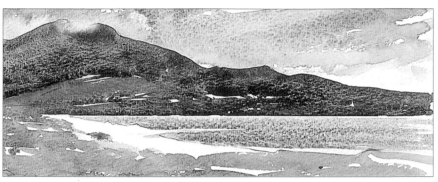

15 Leave to dry, then remove the masking tape to reveal the sharp edge of the far side of the loch.

16 Use a weak wash of manganese blue and long horizontal strokes to block in the surface of the loch, leaving a thin white line below the far shoreline. Lay in touches of permanent magenta across the near side of the loch and allow the colours to blend together. Leave to dry.

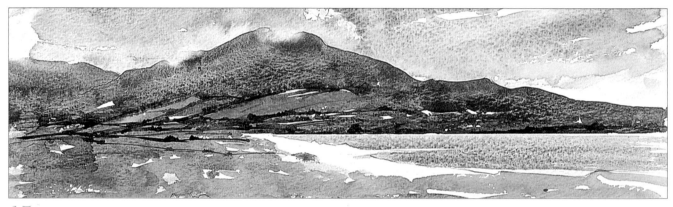

17 Dipping the rigger brush into cobalt blue, brown madder, French ultramarine and permanent magenta, work up shapes on the lower slopes of the mountain (to suggest hedges and foliage) and areas of shadow along the far bank of the loch.

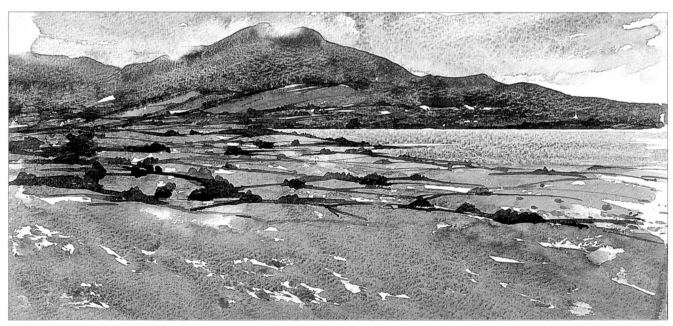

18 Define the near shore of the loch with quinacridone gold and touches of Winsor red. Use a No. 3 rigger and the dark tones on the palette to start defining shapes in the middle distance. These marks should be slightly larger and more spaced apart, slightly stronger in tone and slightly more detailed than those further back.

19 Spatter quinacridone gold, Indian yellow and permanent magenta diagonally across the foreground, spatter some smaller spots of manganese blue into these to create slightly darker tones, then use the brush to blend some of the speckles together to form larger marks. Use the darks on the palette to add a hedge to separate the high foreground from the lower land beyond. Leave to dry.

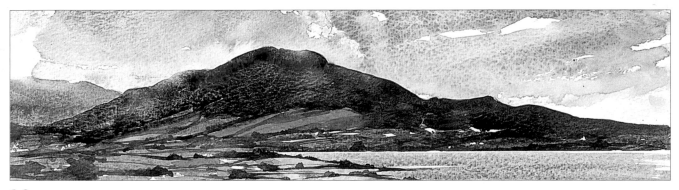

20 Re-wet the soft areas on the mountains, then, dipping a No. 8 brush into French ultramarine, quinacridone gold, permanent magenta and brown madder, apply darker tones to the mountain. Leave to dry completely.

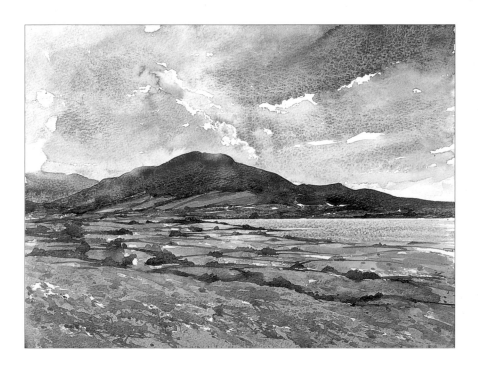

21 Remove all masking fluid. Note that the exposed white areas are very harsh, so they need to be softened in places (see steps 22–24).

22 Use a bristle brush and clean water to soften the two mist-covered parts of the mountain . . .

23 . . . then use a clean paper towel to lift out colour.

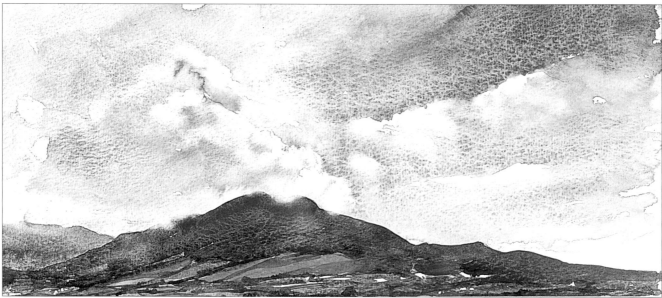

24 Now, using the bristle brush and clean paper towel, rework the whole sky, leaving some hard edges, blending some cloud colours and lifting out some colours to create shape and form.

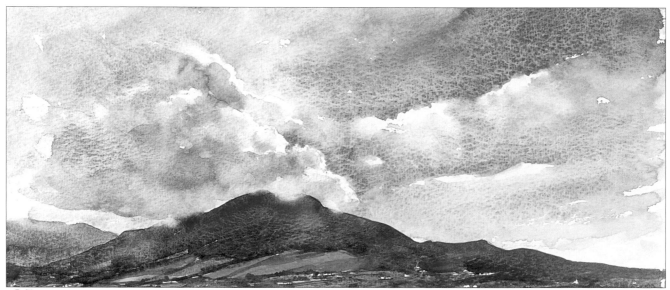

25 Develop shadows in the clouds with permanent magenta, quinacridone gold, cobalt blue and tiny touches of brown madder and French ultramarine. Work small areas at a time, wetting the paper then dropping in the colours.

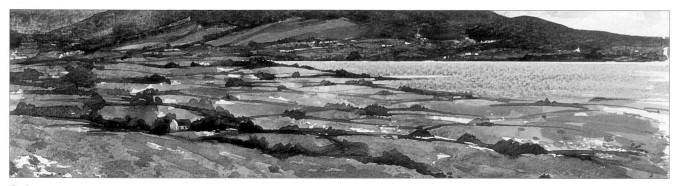

26 Use the darks on the palette to add detail to the small house in the near middle distance. Add small marks to the white patches on the distant shore of the loch to suggest buildings. Strengthen the tones of the foliage between the foreground and middle distance.

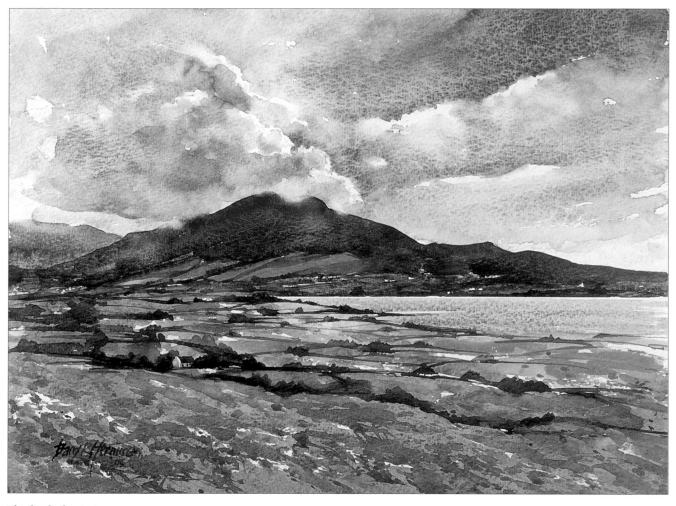

The finished painting.

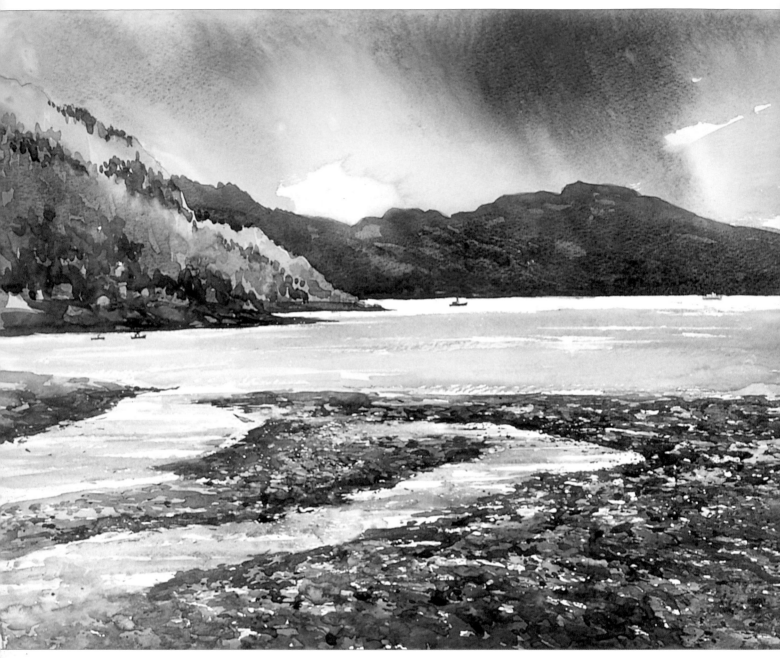

Light on the Loch, Argyll

Size: 620 x 485mm (24½ x 19in)

It had been threatening to rain all morning, but the clouds broke and cast a strong light on the water which was counterchanged by the dark shadowy hills in the background. Quite often, awful weather can produce the most wonderful subjects.

This painting was worked up on a large sheet of watercolour paper as a demonstration piece at an exhibition. When you have a large area to cover, it is best to mix up your paints in large wells before the off; once you start painting, you have to move fast and stopping mid flow can cause some disastrous effects.

The Poisen Glen, Donegal

Size: 395 x 290mm (15½ x 11½in)

I revisit the Poisen Glen every chance I get, and it always seems to catch some really unusual weather. On this particular visit, the crescent-shaped valley was actually glowing in this spectacular shaft of light. It all made for a superb scene filled with real mood and atmosphere.

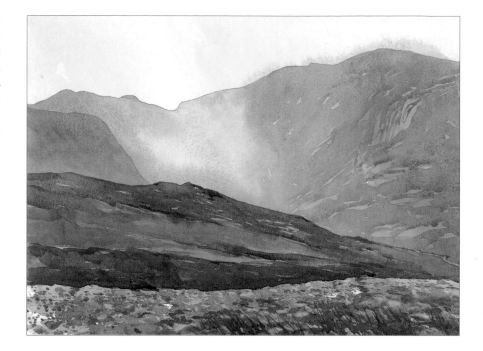

Yorkshire Dales

Size: 490 x 335mm (19¼ x 13¼in)

In complete contrast, this view of the Dales is a much more mellow scene.

The clouds were scudding across the sky casting great shadows over the landscape, then this really strong shaft of light cut a diagonal swathe through the shadows.

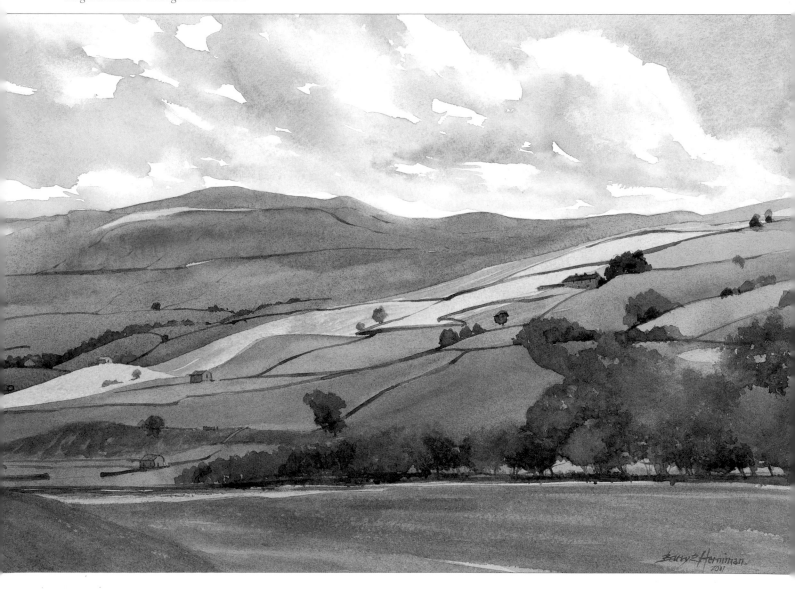

Silver Linings, Fanad, Donegal

Size: 390 x 300mm (15¼ x 11¾in)

This northern tip of the Atlantic Drive in Donegal really catches some weather, especially in winter. This is the view from my friend Keith's house, and I have painted it many times in many different moods. This quiet, unspoilt peninsular, however, is destined for a lot of change if the planned development of a new road bridge goes ahead.

Granulation is very pronounced in this painting. This is the result of tilting the paper from side to side while the paint was still wet.

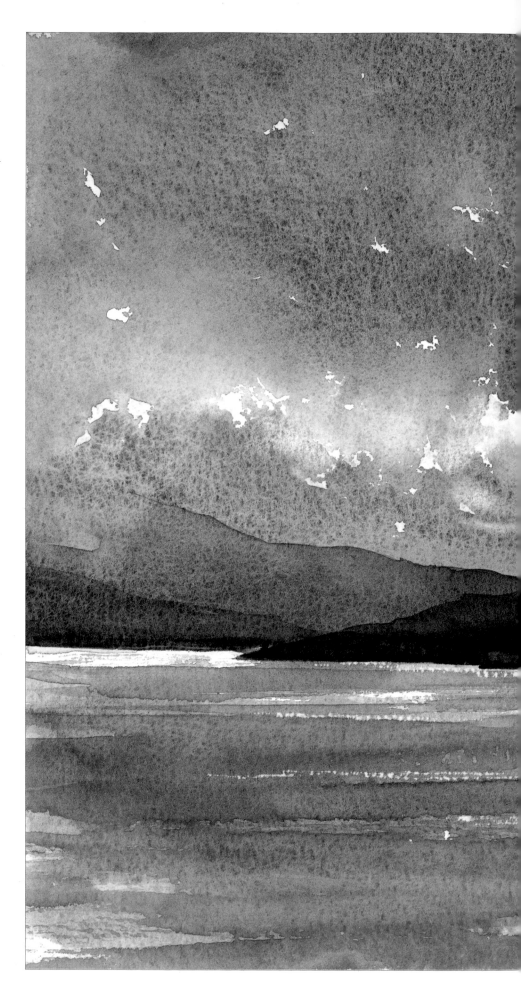

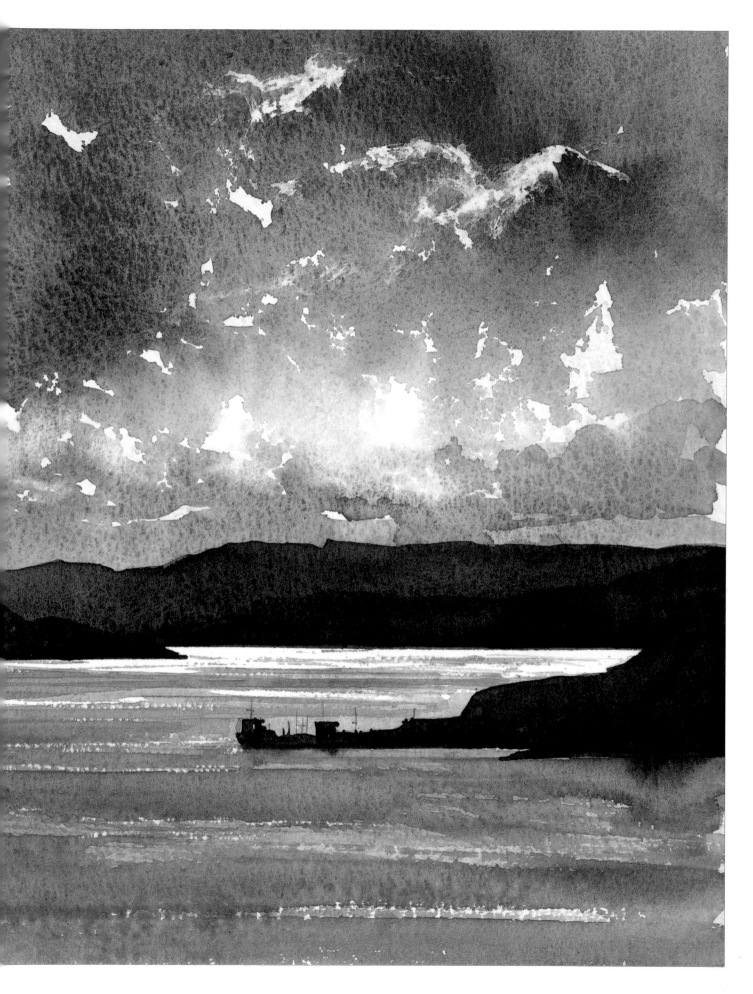

Weathered timbers

New England is a magical place with its lakes, mountains, rivers, streams and wonderful wooden buildings. In autumn, when the trees take on their fall colours, it is even better. This cluster of timber barns caught my eye while travelling up into the Green Mountains of Vermont late in the afternoon. The light was catching the corrugated tin roofs, creating some striking shapes and contrasts, and the well-weathered clapboard sides of the old barn produced some lovely textures. For me it was a perfect combination, so I took the opportunity to take several photographs and copious notes.

I used one of these photographs as a reference for this demonstration in light and shade, playing off the harsh angular lines of the buildings against the softer, rounder shapes and random quality of the foliage and undergrowth. I like the finished painting very much, so I think I will be painting these buildings quite a few more times before I tire of them.

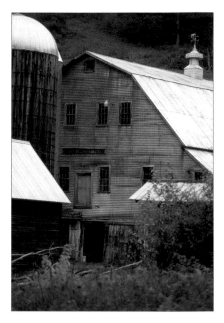

One of several reference photographs taken during a painting holiday in Vermont. You never know when you might stumble on scenes such as this, so never travel without your camera.

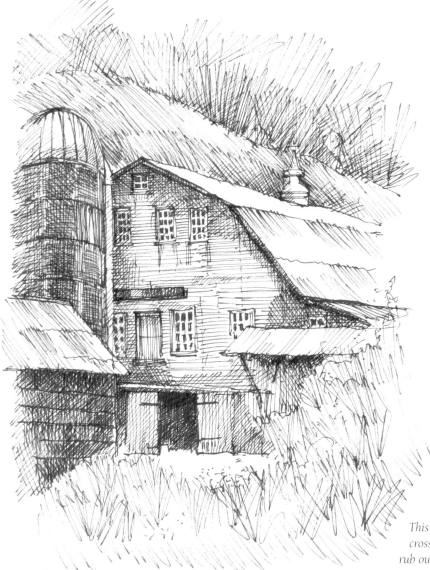

This quick tonal sketch was worked up with sepia ink, cross hatching to build up the dark areas. You cannot rub out ink, so all the lines have to be decisive and bold.

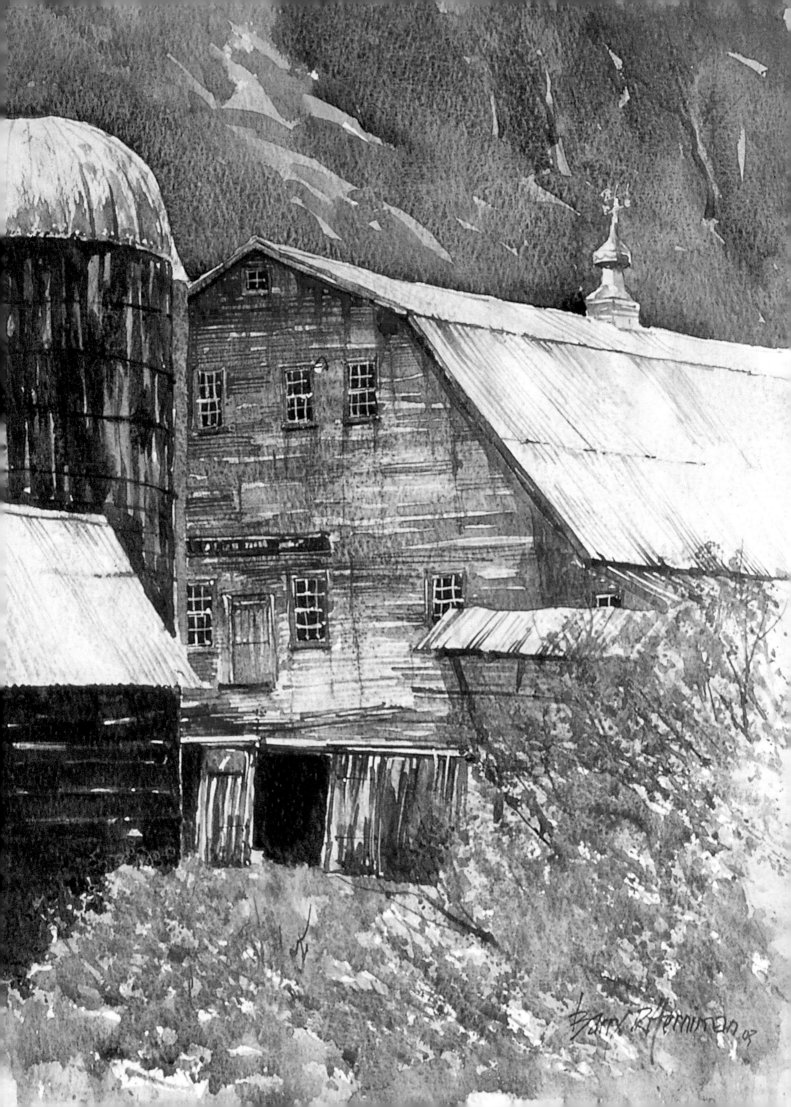

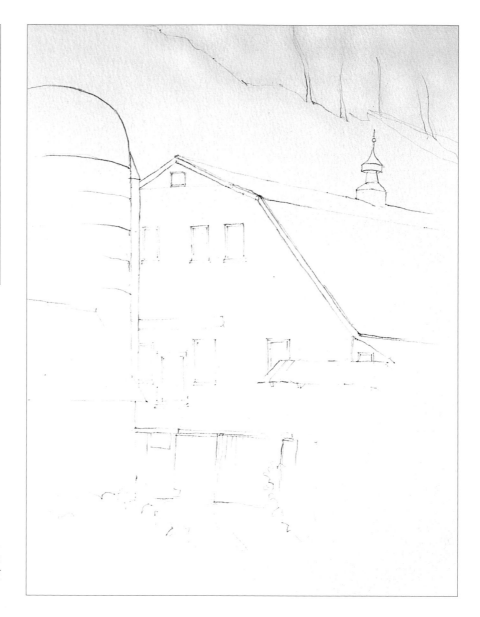

1 Referring to the tonal sketch and photograph on page 54, use a 2B pencil to transfer the basic outlines of the composition on to the paper.

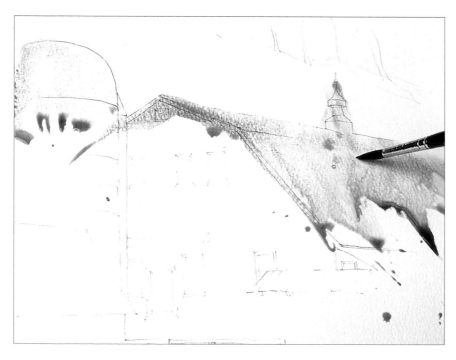

2 Prepare the initial washes: cobalt blue, quinacridone gold, permanent magenta, cobalt turquoise light, alizarin crimson and manganese blue. Wet the top edges of the buildings, then use the No. 16 brush to lay manganese blue into the roof of the large building and the top of the silo. Working quickly, wet in wet, pull the colour down the paper (roughly following the shape of the roofs) and drop in touches of alizarin crimson, cobalt turquoise light and permanent magenta . . .

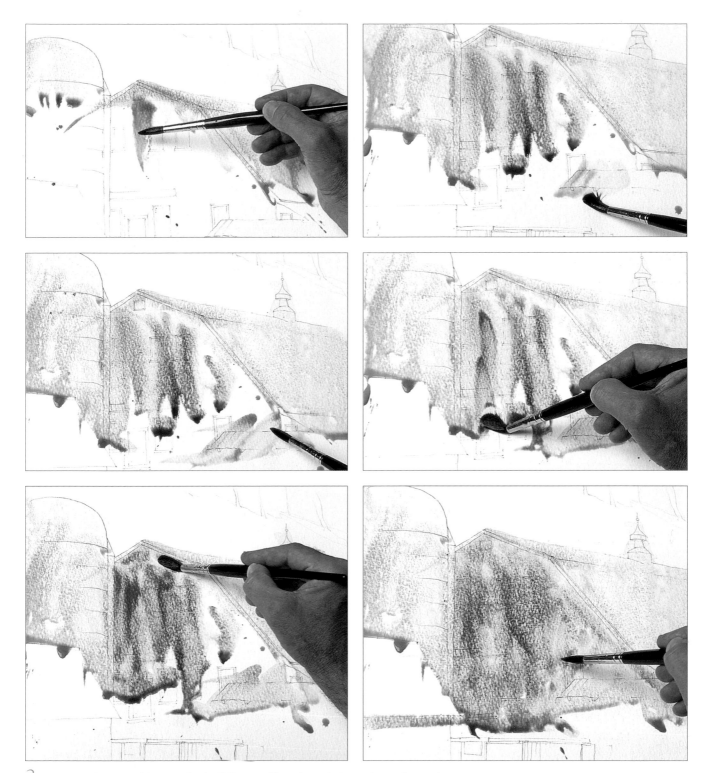

3 . . . continue working on the buildings pulling the existing colours down the paper, adding more colour wet in wet and allowing these to blend together to create the desired tonal effect . . .

4 . . . then, while the colours are still wet, start to work on the foreground.
Develop the background tones for the two smaller buildings, centre and left, then
start to work up the foliage. Use a No. 8 brush to spatter quinacridone gold,
permanent magenta and cobalt blue, then use the handle of the brush to draw
some of the spatters together to create the rough texture of foliage. While these
colours are still wet, flick in some bright accents of cobalt turquoise light.

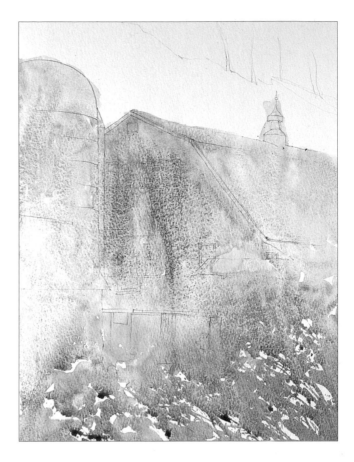

5 Mingle and merge the colours across the entire width of the foreground, then complete the initial washes by spattering colour up into the damp area of the buildings at right-hand side to suggest more open foliage.

6 Leave the initial washes to dry completely.

7 Turn the painting upside down, then, working down from the hard edges of the tops of the buildings, lay in the background washes of quinacridone gold with touches of manganese blue and cobalt blue. Start wet on dry, then work fresh colour into the wet ones on the paper.

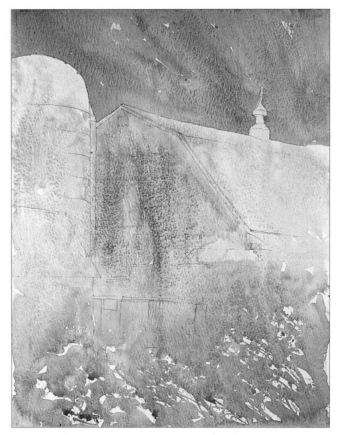

8 When the background wash is complete, leave the painting to dry.

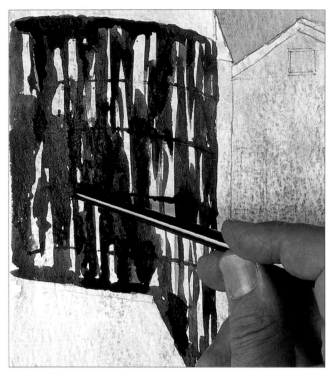

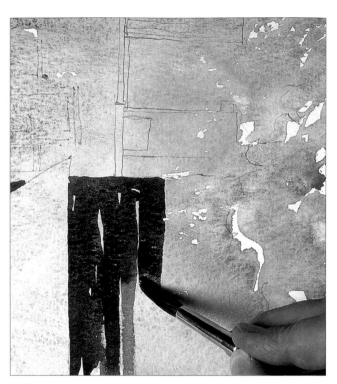

9 Use a No. 10 brush with brown madder and touches of French ultramarine to work on the grain silo. Drop in colour along the top edge of the side of the silo, then drag down streaks of rust and water marks. Cut along the edges of the roof of the building in front of the silo. Spatter on a few specks of quinacridone gold and allow these to blend with the darks. Using the handle of the brush, draw through the wet paint to indicate the curved sections of the silo.

10 Turn the painting on its side, then use the same colours to paint the planking of the wall on the small building below the silo.

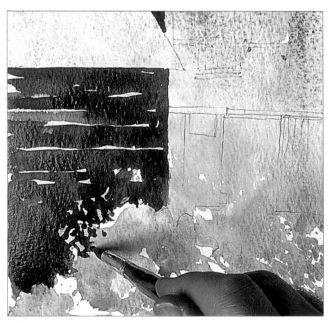

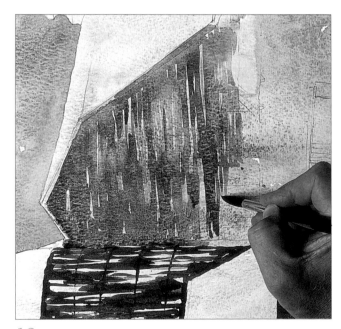

11 Continue working down to the top of the foliage, turn the painting right way up, then trickle colour along this edge. Soften some of the marks with clean water.

12 Turn the painting on its side and use the No. 10 brush with cobalt blue, manganese blue, permanent magenta, Winsor red and French ultramarine to lay in the planking on the large building. Work wet on dry, then wet in wet, laying in streaks of colour. Suggest the deep shadow under the eaves with darker tones.

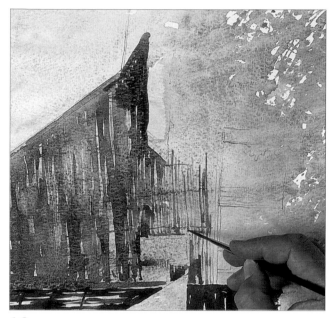

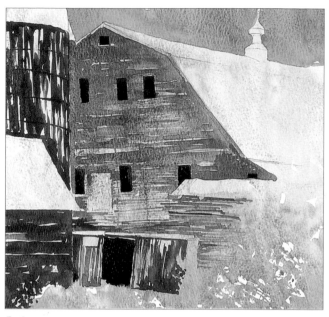

13 Continue working colour into colour to build up random tones, then use the handle of the brush to reinstate the outline of the doors and windows. The bottom of the building has reflected light from the structures around it, so use the rigger brush to define the planking in this area.

14 Cut round the small pitched roof on the front of the building, turn the painting the right way up, then use a mix of French ultramarine, permanent magenta and brown madder to block in the windows. Use the same colours to start defining the shapes for the foreground building.

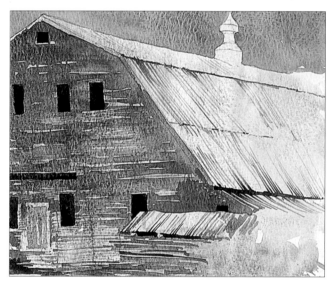

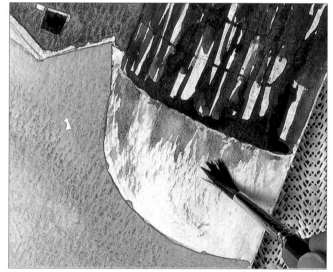

15 Block in the long signboard above the door, then use the rigger brush with manganese blue, permanent magenta and cobalt blue to develop the texture on the corrugated iron roofs. You only need an impression, so do not try to reproduce every undulation. Then, using the darks on the palette, define the shadows along the edges of the roof.

16 Turn the painting upside down, then use a semi-dry brush loaded with cobalt turquoise light and permanent magenta to paint the top of the silo; drag the brush lightly over the undercolour, varying the angle of the stokes to follow the curve of the top of the silo.

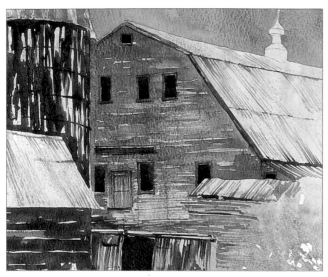

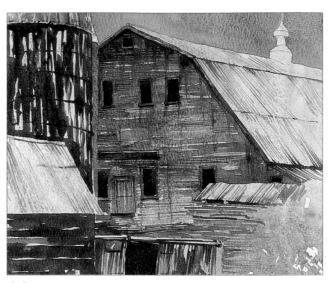

17 Define the corrugations on the roof in front of silo as before. Then, still using the rigger and a mix of cobalt blue, quinacridone gold and permanent magenta, define the window frames and doors on the barn. Use the same colours to paint the barge boards that edge the roof.

18 Use the rigger brush with French ultramarine, cobalt blue, brown madder and a touch of alizarin crimson to lay in deep shadows under the eaves; pull down vertical streaks of colour to suggest water stains. Darken the left-hand side of the large building so that the second silo becomes obvious.

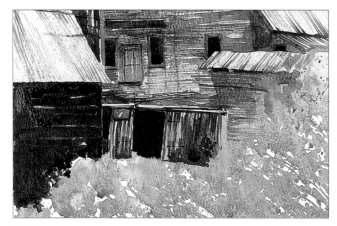

19 Use the same colours to strengthen the tones on the front of the left-hand building.

20 Use the rigger to define the detail on the air vent.

21 Develop the background. Use the No. 12 brush with quinacridone gold, cobalt blue and touches of permanent magenta, to lay in random patches of dark tones to suggest foliage. Carefully cut around the shape of the air vent and the top edge of the roofs.

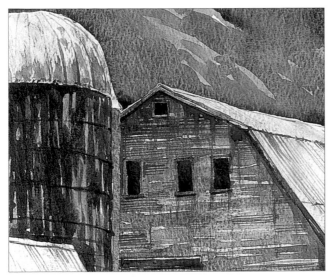

22 Lay in a wash of quinacridone gold over the right-hand side of the silo.

23 Develop the foreground foliage by spattering all the colours in the palette. Scrape the handle of the brush through the spattered colours to suggest stalks and twigs.

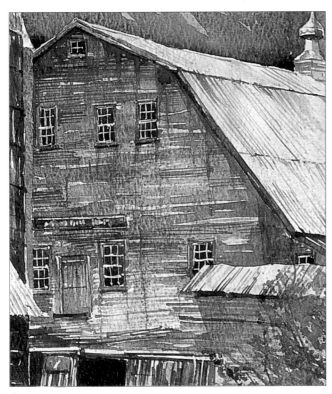

24 Working on a separate palette, tint some white gouache with touches of cobalt turquoise light and a brown from the watercolour palette, then use the rigger to define the window bars and to suggest wording on the sign.

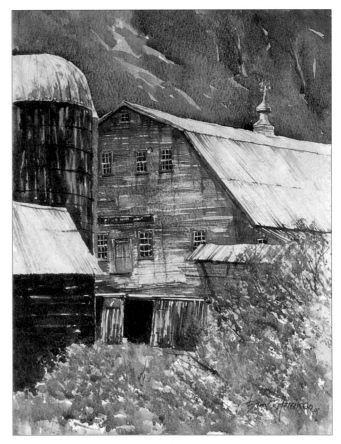

The finished painting. Having stood back to look at it at the end of step 24, I realised that I had omitted the support for the small pitched roof on the front of the barn. I painted this with a rigger brush and a mix of brown madder and ultramarine. I then added some more foliage to cover the bottom of the support.

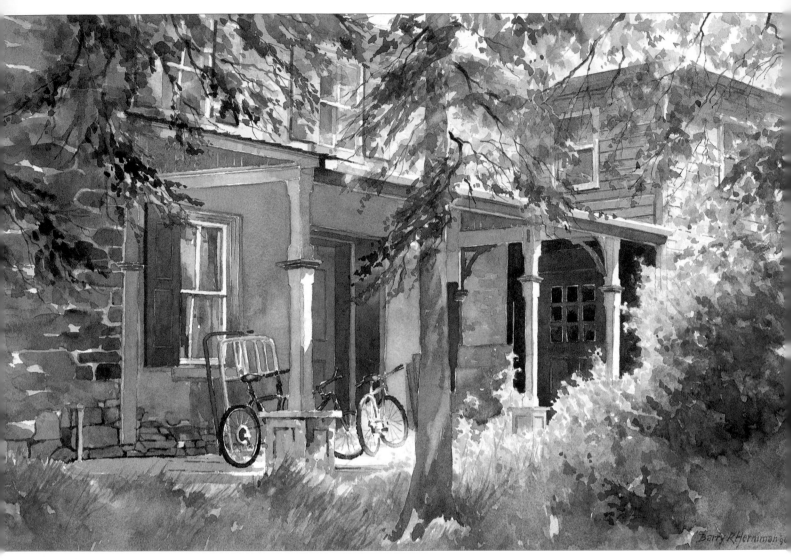

Ferbotniks Porch, Pennsylvania

Size: 520 x 340mm (20½ x 13½in)

A scene of strong light and sharp contrasts. This wonderful porch was built on to the side of an old farmhouse in Bucks County – a very pretty county in Pennsylvania. I was on a search for old-style barns and bridges and came across this farmstead with its coloured timber frame and doors. With the kids' bikes plonked up against the wall, this scene said, 'lazy days', to me. The afternoon sun was catching the pink uprights of the porch, contrasting with the darker red doors.

Opposite above

Two Bridges, Marsh Bridge, Somerset

Size: 520 x 340mm (20½ x 13½in)

My Dad and I went on a trip down memory lane, visiting the area where he was brought up as a child. He took me to some of his old haunts and this scene on the Barle River was one of them.

The whole day was rather dull and overcast but even so there was a soft muted light throughout the scene, which I rather liked.

A very low-key picture, with its subtle contrasts and colours, but a very atmospheric one. I went back a few years later and the sun was shining; an altogether different scene!

Opposite

La Fuente, Zuheros, Spain

Size: 390 x 285mm (15¼ x 11¼in)

Zuheros is a small village perched on the side of a mountain in Subbetica Natural Park – a two-hour drive north of Malaga.

This is a study of light and shade with underlying warmth. Although more than half of the picture is in shadow it is not cold, as I infused the shadows with rich, warm reflected colours, which make them glow.

When it is hot here, it is very hot, so I bleached out some of the colour from the sunlit areas to intensify the feeling of heat.

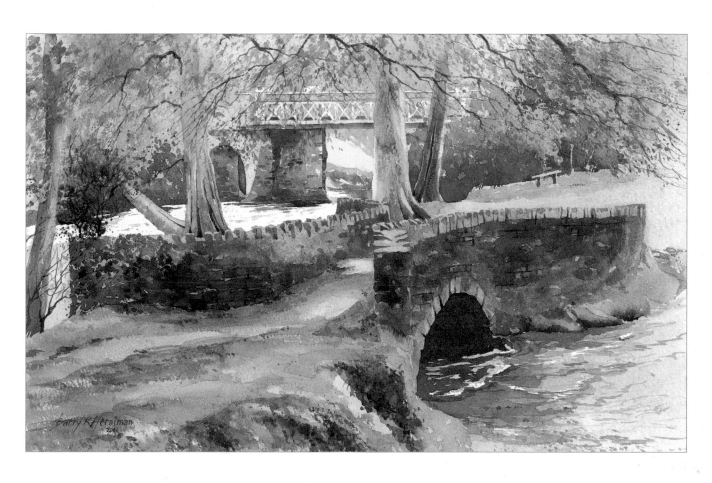

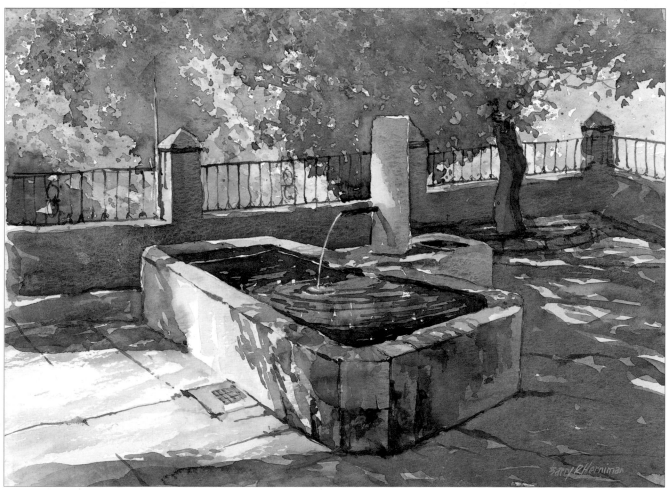

Frosty morning

When you have lived in an area for a while, it is easy to become complacent with the surrounding scenery – familiarity, and all that! You tend to go searching further afield (excuse the pun) for that great subject, when it could be waiting for you just round the corner.

This is a scene from my small corner of Herefordshire. I know every inch of these fields, but it never ceases to amaze me just how different the scene becomes when the light changes and the seasons move on. It just goes to show that the combination of weather, lighting and season can produce some wonderful painting subjects right on our doorsteps.

On this particular late autumn morning, the first frosts had arrived. The air was crisp and clear, and the sun had just risen above the background hills. There was a lovely warm glow over the whole of the countryside, and the sun was shining through the trees in the foreground. Because of this, I was able to look directly at the scene without being blinded and capture the bright light that silhouetted the trees.

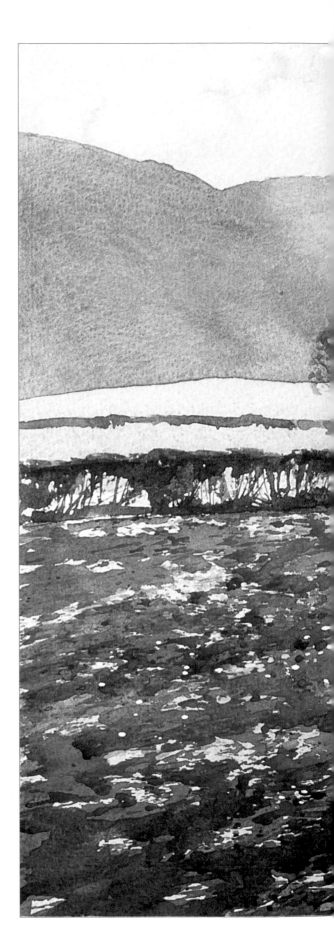

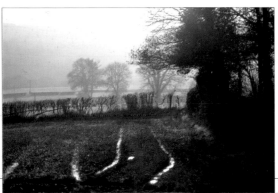

I got out my water-soluble coloured pencils for this quick preliminary sketch. I hatched in yellow over most of the picture, leaving white areas around the trees, built up the colours with a series of overlays, then softened some of the areas with clean water. I changed the angle of the tractor tracks so that they entered the composition from the bottom-right.

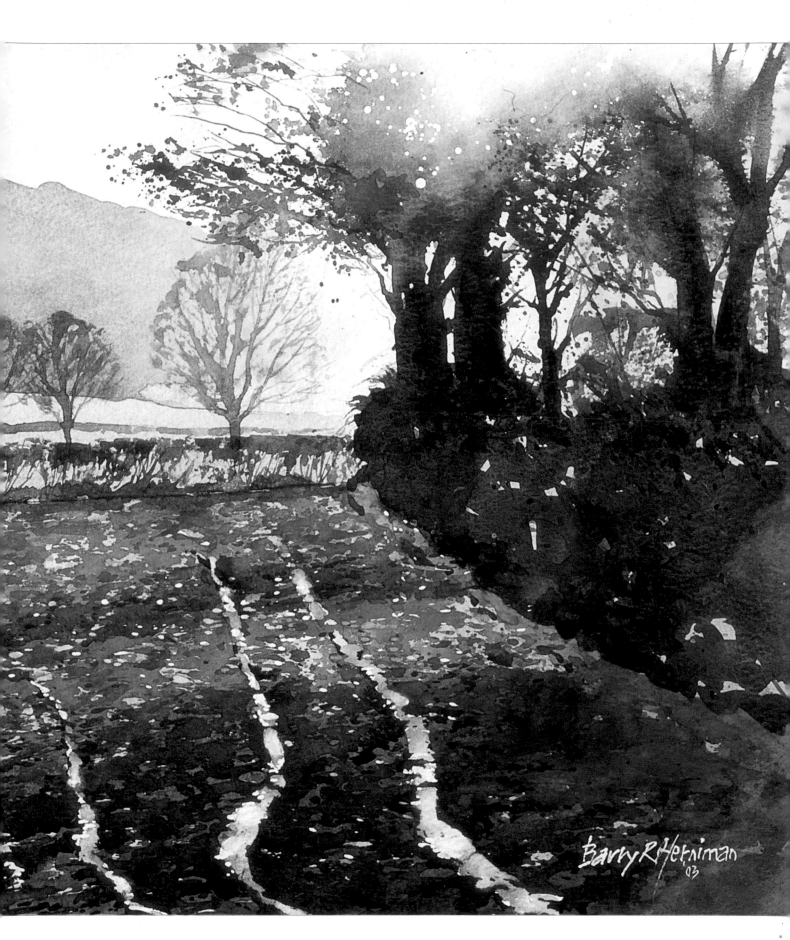

1 Transfer the main outlines of the composition on to the watercolour paper. Note that the detail on the left-hand side of this composition is barely suggested. Apply masking fluid (tinted here with a touch of manganese blue) to the icy water in the wheel ruts in the field. Spatter some into the top of the tree at the right-hand side, then across the foreground as frosty highlights on the ploughed field. Prepare the initial washes: aureolin, Indian yellow, quinacridone gold, Winsor yellow, Winsor red and manganese blue.

2 Spray a liberal amount of clean water over all the paper . . .

3 . . . then, working quickly and leaving the highlight area among the trees as white paper, start to lay in Winsor yellow, aureolin and Indian yellow.

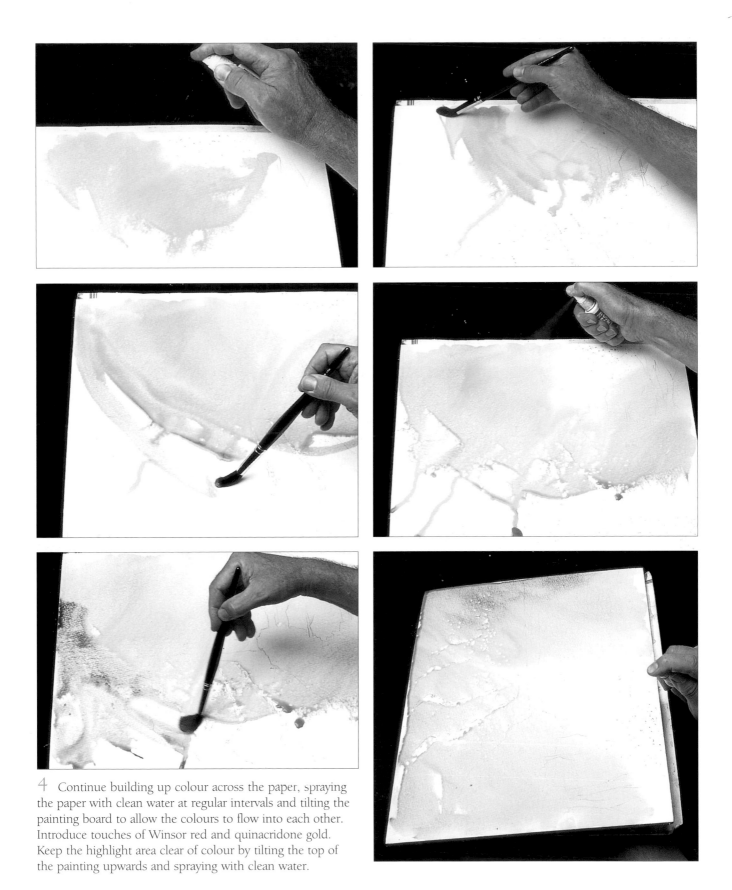

4 Continue building up colour across the paper, spraying the paper with clean water at regular intervals and tilting the painting board to allow the colours to flow into each other. Introduce touches of Winsor red and quinacridone gold. Keep the highlight area clear of colour by tilting the top of the painting upwards and spraying with clean water.

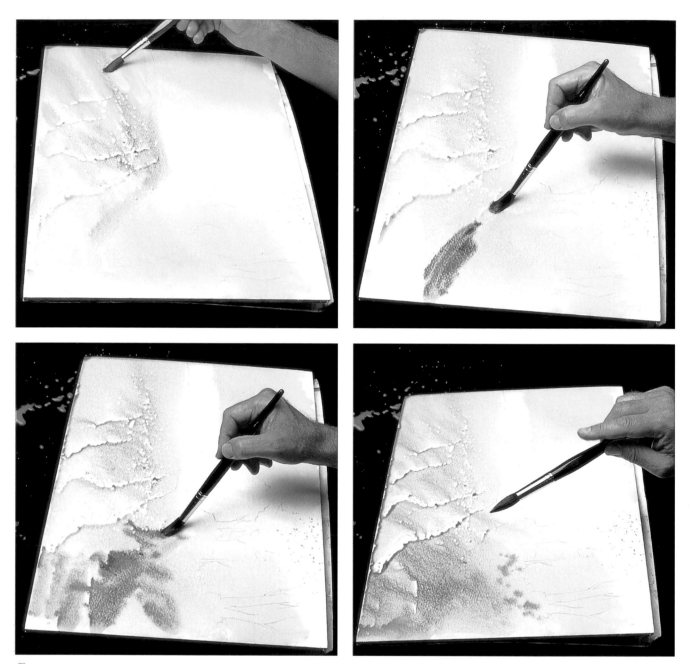

5 Still working quickly, wet in wet, add more Indian yellow at both the left- and right-hand sides. Lay in a weak wash of manganese blue to define the background area where the hedges are. Add Winsor red and quinacridone gold across the right foreground area, then spatter more quinacridone gold wet in wet.

 When laying in my initial washes, I am continuously tilting and turning the paper to allow the colours to blend on their own. In the series of photographs above, the top of the painting is at the right-hand side.

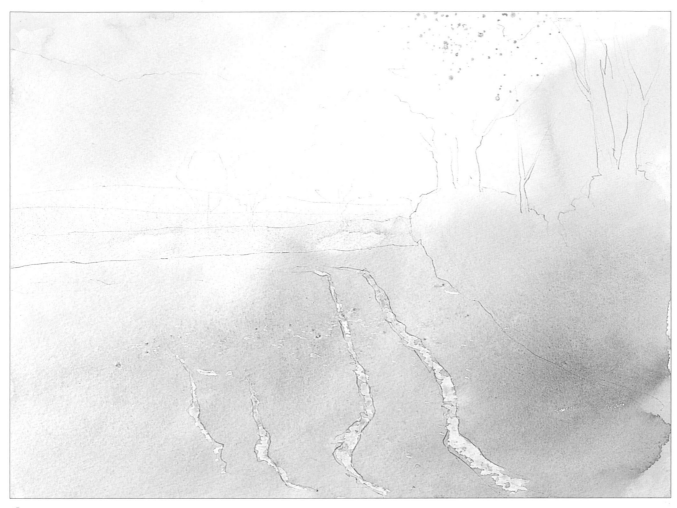

6 Leave the initial washes to dry.

7 Turn the painting on its side, then, working wet on dry, use the No. 12 brush to apply cobalt blue, with touches of French ultramarine and rose madder genuine, into the distant hillside . . .

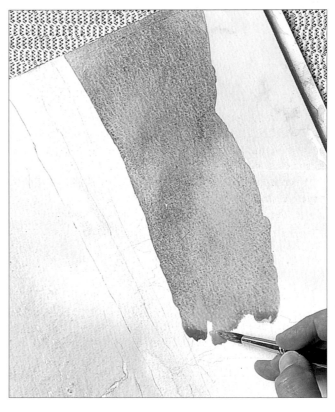

8 . . . work down (across) the paper, adding more of the same colours, and introducing Winsor yellow to give a warmer glow towards the right-hand trees.

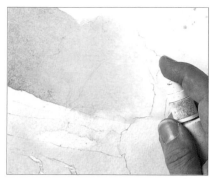

9 When you get close to the right-hand trees, spray the Winsor yellow with water, then use paper towel to absorb any excess paint.

10 Leave the painting to dry.

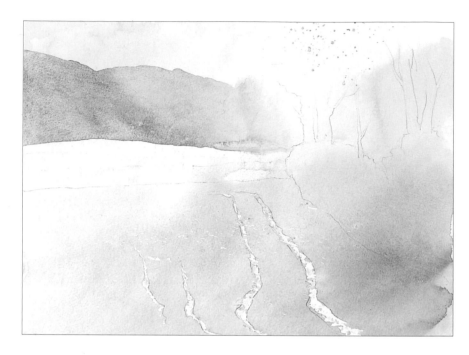

11 Turn and tilt the painting board, then use the No. 10 brush to spatter the foreground with water followed by Winsor yellow and quinacridone gold. Use your other hand to mask the edge of the field.

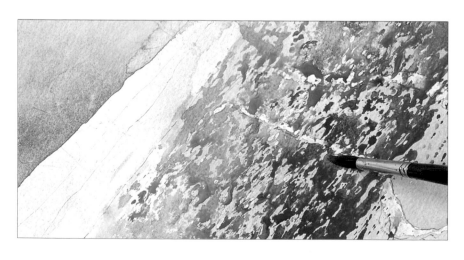

12 As you work down the field, spatter more water followed by Winsor red, more Indian yellow and brown madder. Spatter some cobalt blue to create darker tones. Gently move the paint around with the brush to pull the colours together.

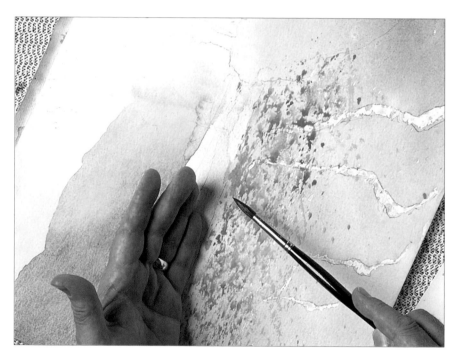

13 Mask the middle distance with a sheet of paper, then, tapping the side of a loaded brush with your finger, spatter smaller marks of the previous colours over the foreground.

14 Darken the right-hand corner of the foreground with cobalt blue to create shadow areas. Then, keeping the painting angled down so the paint runs and colours mingle, bring this colour across over the centre of the foreground. Use the brush to soften the edges.

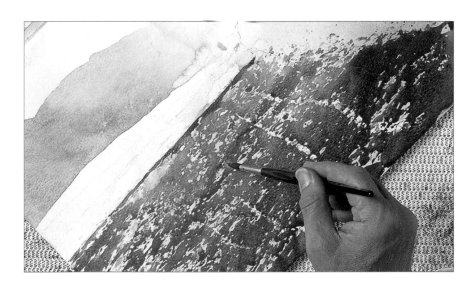

15 Use cobalt blue and brown madder to introduce a shadow area under where the hedge will be. Use the same colours to work smaller shadows in the field. Leave to dry.

16 Now start to work on the right-hand trees. Spray the paper with clean water, then, masking the paper with your other hand, use the No. 8 brush to spatter Indian yellow into the tree. Mop up excess water and colour with clean paper towel.

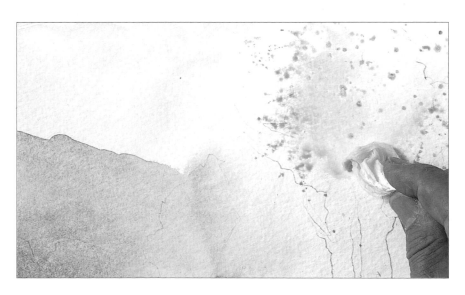

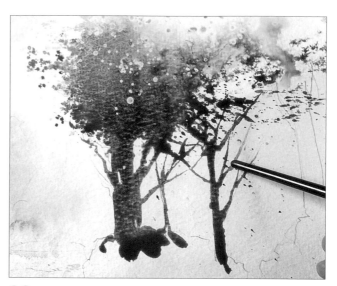

17 Spatter quinacridone gold into the damp yellow and allow colours to merge. Raise the top of the painting, then add brown madder and cobalt blue to the lower area.

18 Allow the colours to merge then pull the bead of colour down to form the trunk. Use the handle of the paint brush to pull the colour down to form two smaller trees. Spatter dark tones of colour to suggest foliage on these trees.

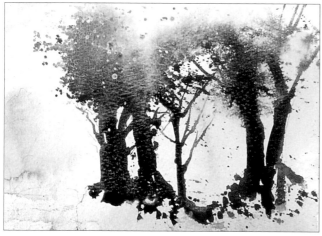

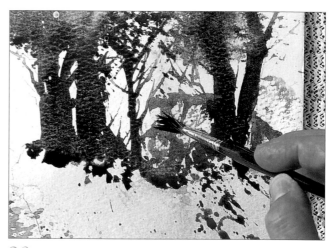

19 Spray the foliage area with water, then paint the two right-hand trees. While the paint is still wet, add touches of French ultramarine on the shadowed sides of the trunks.

20 Spatter more foliage wet in wet, then pull out more branches. Drag the side of the brush over the surface to create background foliage between the trees.

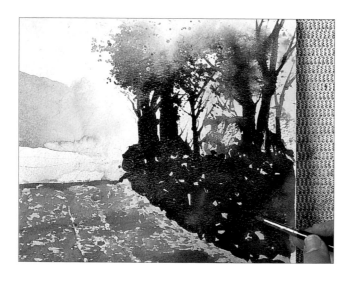

21 Use French ultramarine with touches of rose madder genuine to accentuate the branches and shadows. Bring these colours down over the area beneath the trees, then introduce touches of brown madder and cobalt blue.

74

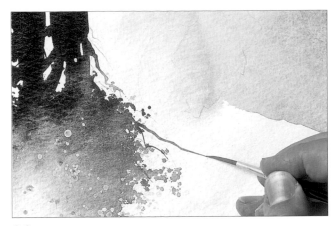

22 Turn the painting upside down, then use the rigger brush with brown madder and cobalt blue to paint some thin branches.

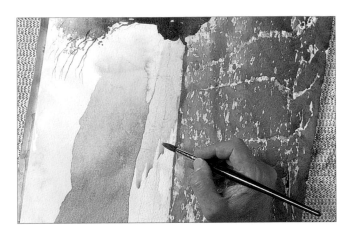

23 Turn the painting on its side so that the colours will run down the paper, then use a No. 12 brush to apply a flat wash of Winsor yellow over the middle-distant fields.

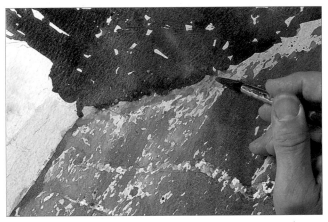

24 Working into the drying edge of the woodland, add a band of Indian yellow down the edge of the field where it meets the wooded area.

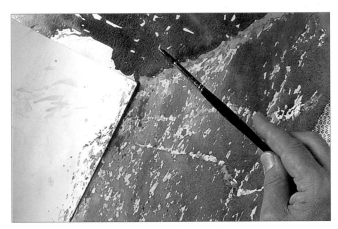

25 Still working at an angle, mask the middle distance with paper, then, painting wet on dry, use the No. 8 brush to flick darker tones of quinacridone gold into the foreground field.

26 Spatter more quinacridone gold, cobalt blue and the reds on the palette into the field, then push and pull the colours together. Develop the distant edge of the field.

27 Suggest undulations in the field by creating areas of shadow with the dark colours on the palette.

28 Use a No. 10 brush to spatter more reds and cobalt blue on the near foreground. Add touches of French ultramarine, then blend the colours with the brush.

29 Use the same colours to develop the whole width of the foreground. Add some dark shadows at the right-hand side of the field.

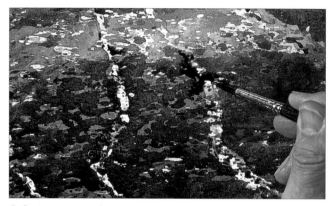

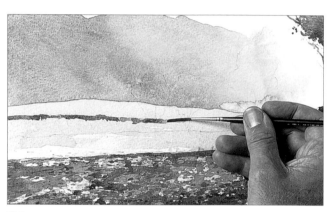

30 Accentuate the ruts in the field by creating shadows with touches of French ultramarine and brown madder. Spatter these colours over the foreground as you work.

31 Working wet on dry with a No. 3 rigger brush, lay down flat brush strokes of cobalt blue, quinacridone gold, Indian yellow and rose madder genuine to form the more distant of the two hedges.

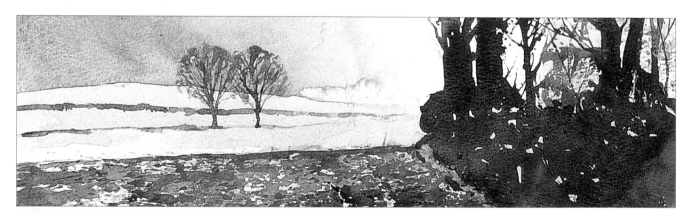

32 Weaken the colours as you work towards the right-hand side. Lay in another band of the same colours to form the nearer hedge. Create the trunks and branches of two trees then, using a damp brush, drag it across the surface of the paper to suggest some foliage.

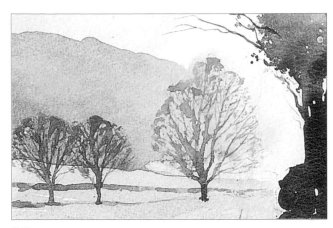

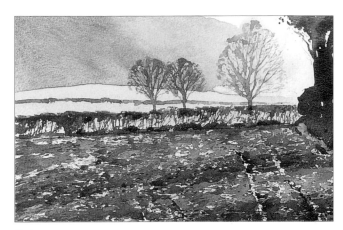

33 Now use a weak brown wash to work up a larger tree to the right of the others. While this is still wet, drop in a blue wash on the shadowed side of the trunk and branches. Work up some foliage with quinacridone gold and touch of brown madder. Notice that there is more detail on the left-hand side; the right-hand side is blurred by sun.

34 Using a No. 8 brush, apply downward, near-vertical, dry brush strokes of brown madder, cobalt blue and quinacridone gold to form the top of the hedge. Use similar colours and upward strokes to form the bottom of the hedge, then use the rigger brush to link the top and bottom parts of the hedge. Add touches of quinacridone gold to the brighter right-hand end of the hedge.

35 Remove all the masking fluid in the field and in the large sunlit tree. To remove large areas of masking fluid, lift one edge and carefully pull the rest off the paper.

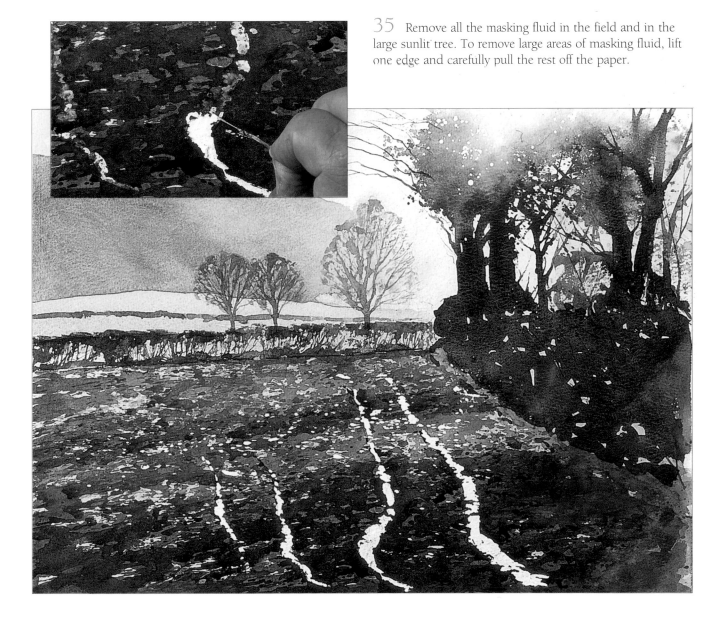

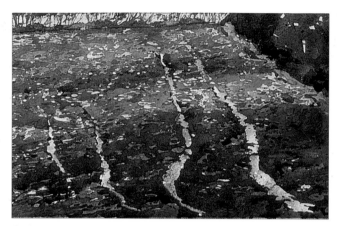

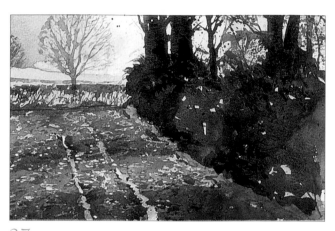

36 Brush Winsor yellow, with touches of quinacridone gold, into the icy ruts in the field and over some of the white highlights created by the masking fluid.

37 Spatter darks from the palette into the deep shadowed area at the right-hand side. Trickle more colour into this area, then use the brush handle to create 'squiggles'. Spatter a few specks of quinacridone gold.

38 . Use the No. 8 brush and delicately spattering to suggest foliage on the bare branches of the trees at the top of the painting. Pull the brush handle through the paint to redefine the structure of branches.

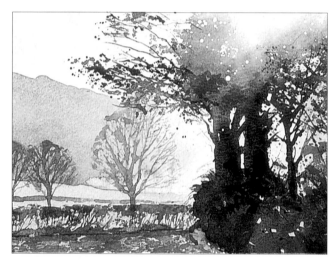

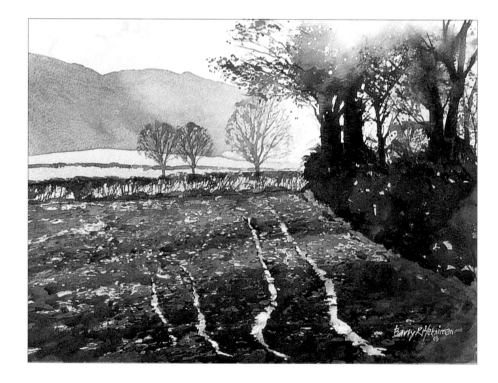

The finished painting. Having stood back to look at the painting at the end of step 38, I decided to use a bristle brush, clean water and some paper towel to lift out a few highlights from the icy ruts.

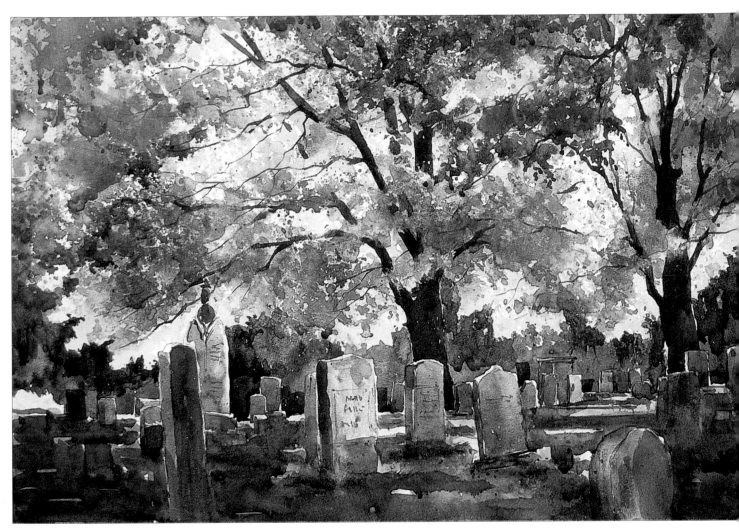

Sunlight in the Cemetery, Belmont, USA

Size: 520 x 340mm (20½ x 13½in)

The sunlight shining through these autumn leaves was almost blinding.
The leaves were made all the more dramatic by contrasting them with
the purple shadows and gravestones. I used pure colours for the leaves:
yellows, reds and golds straight from the tube.

Overleaf
First Frost at Way-go-Through, Llangarron

Size: 535 x 335mm (21 x 13¼in)

This is one of the walks around our village which we have done many
times. This particular morning there had been a heavy frost. The early
morning sun was just filtering through the trees infusing intermittent
areas with warmth in an otherwise cold scene.

I flicked and spattered paint over the foreground making the colours
progressively cooler the further they were from the light source.

This painting is reproduced by kind permission of the owners,
Jacqs and Ken Anstiss.

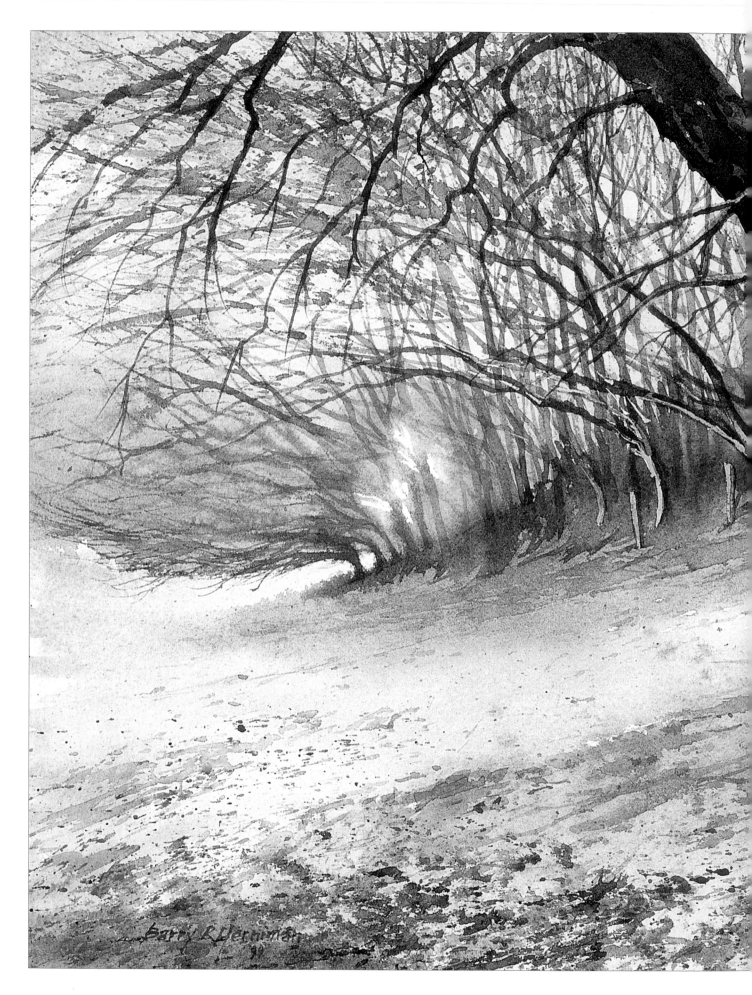

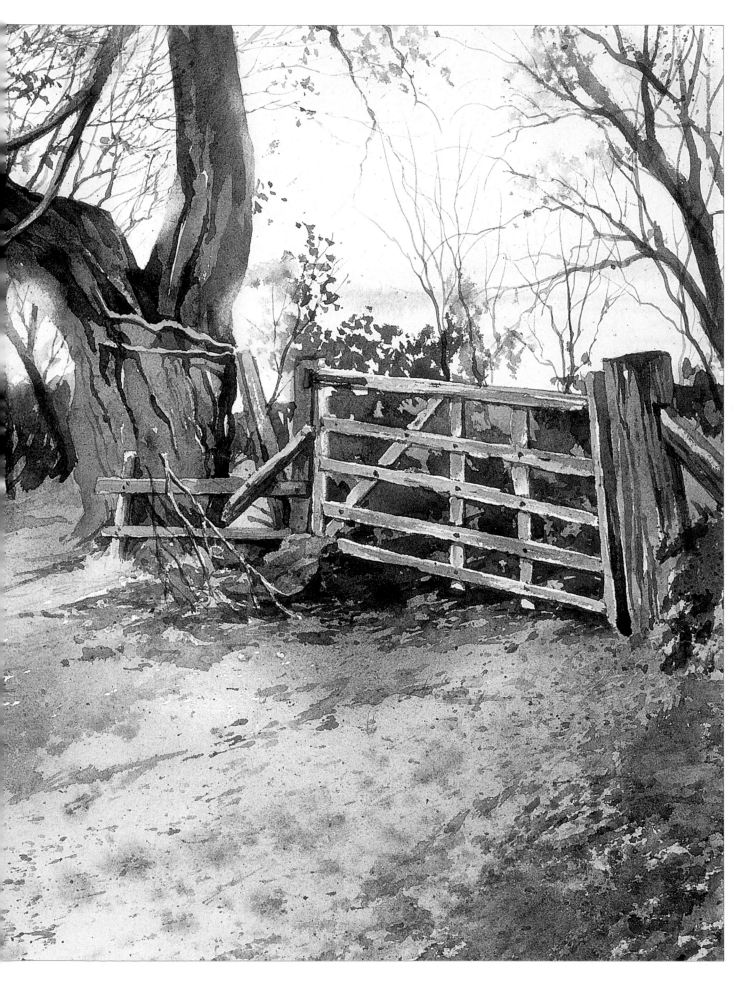

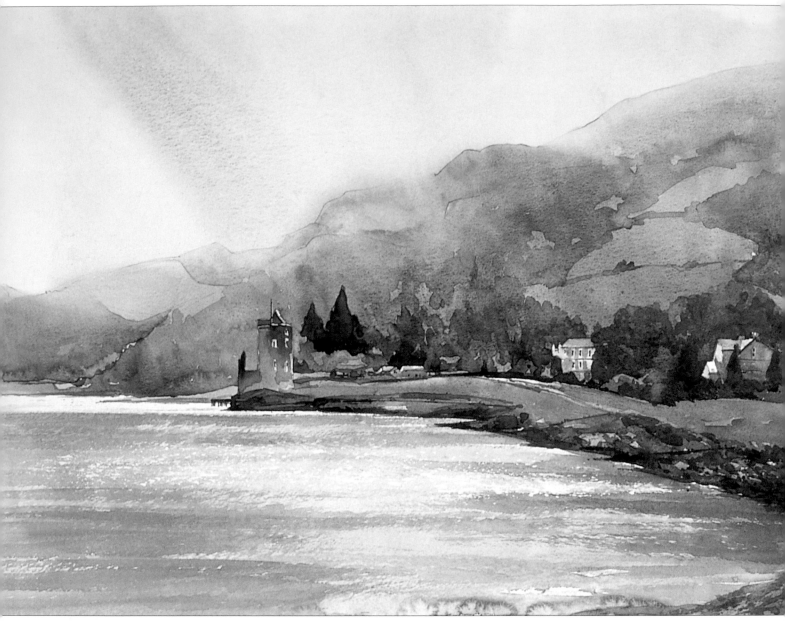

Scottish Solitude, Argyll

Size: 630 x 465mm (24¾ x 18¼in)

A rather 'soft' Scottish day, but with some strong accents of light around the small castle on the edge of the loch.

The rather milky clouds were obscuring the hillside in places so I kept the whole painting low key to accentuate the mistiness.

This was a demonstration painting to show how a build up of glazes can capture the transient light that was visible over the loch.

Fall, New Jersey

Size: 380 x 290mm (15 x 11½in)

On one of my trips to America, I had left Vermont (where the fall colours were in full flow) and travelled down to New Jersey to find that most of the foliage was still green. I was heading up into the hills beyond a small village when, almost by accident and to my complete surprise, I came upon this stream where the leaves had started to turn. Rather than use masking fluid, I reserved my whites by painting around them – a practice which produces a lively, spontaneous painting.

Making Tracks, Llangarron

Size: 490 x 320mm (19¼ x 12½in)

Our local farmer had left this field fallow over the winter and there was a lot of old growth still evident. With the heavy frost and the glowing light the whole scene was a patchwork of colour – lights and darks, warms and cools – all dancing together.

This is fine example of an ordinary scene being transformed by special lighting conditions. Always keep a look out for the extraordinary, even when your surroundings are totally familiar.

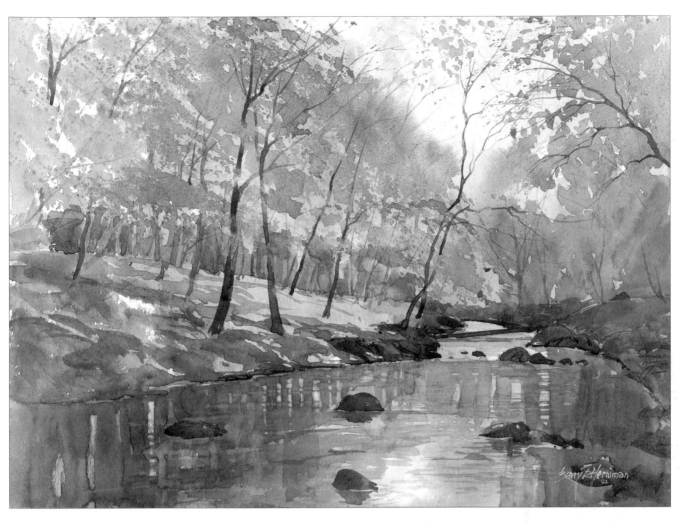

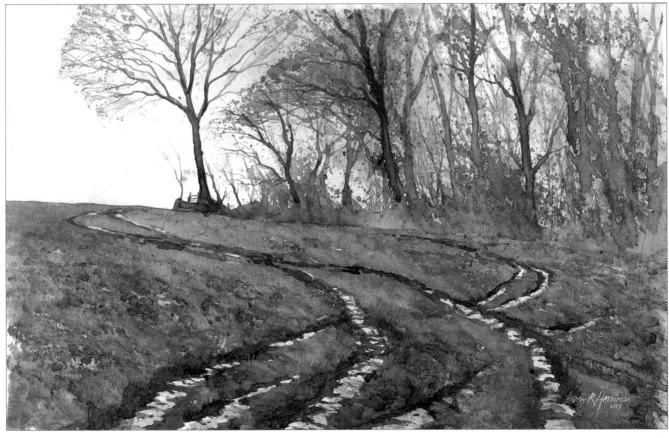

Harbour 'lights'

I first went to Tenby with my brother about four years ago, and have been going back year after year ever since. I never tire of the Pembrokeshire coast, and Tenby in particular, as it offers a wealth of painting subjects in all weathers. Whenever I am painting down there, I take an early morning stroll on South Beach (when the tide is out) and up into the harbour. On one particular morning the sun had not risen above the rooftops but the pervading light was bouncing about between the houses and alleyways. The whole scene had a warm, rosy glow which was evident even in the shadows.

The sluice, the local name for this dry dock, was almost in total shadow but some of the morning light was filtering between the buildings and lighting up a few details. I wanted to capture the quietness and tranquillity of the small boat moored to the harbour wall, with the two men in casual conversation, one in the boat and the other on the wall.

This photograph and the tonal sketch were used as reference material for this step-by-step demonstration.

The overall scene had a rather large lifeboat in the foreground, and there were a lot of mooring ropes cutting across the field of view. These would have made the picture rather messy, so, in the tonal sketch, I closed in on the small boat, simplified the ropes and concentrated on the shapes and tones. I used 2B and 4B water-soluble pencils to draw the sketch on a square block. For the painting, however, I wanted to get a better feeling of depth so I painted it in portrait format.

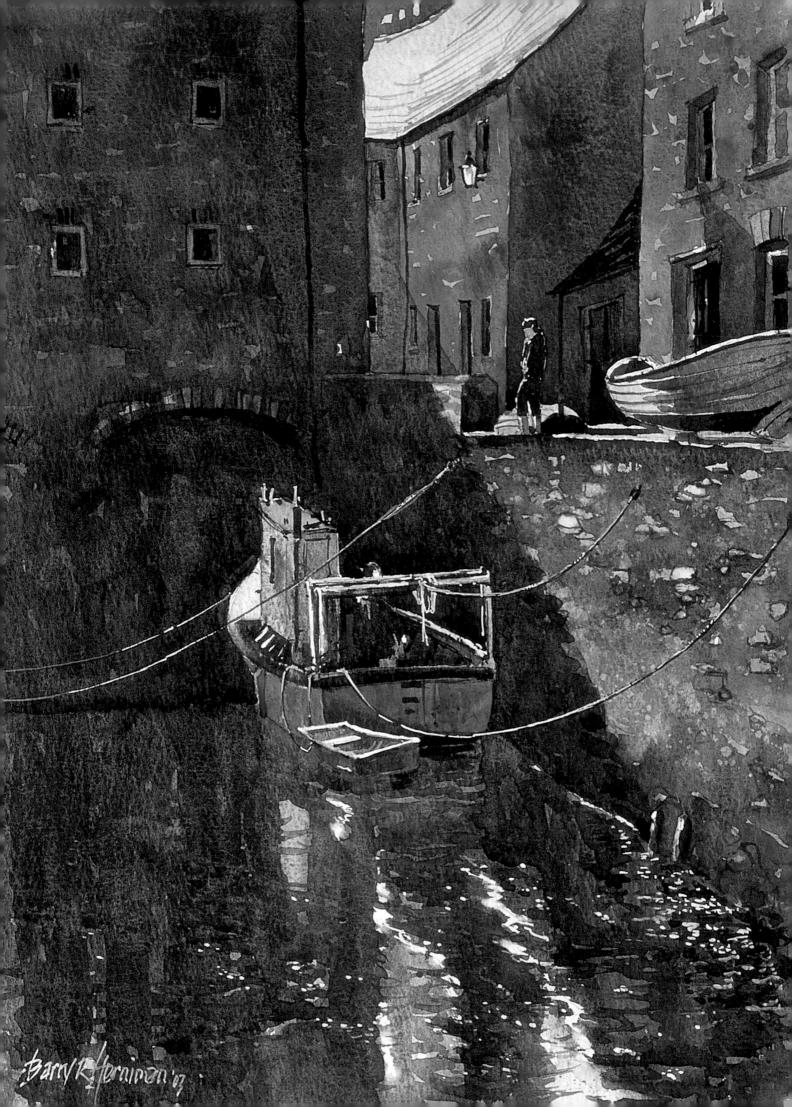

You WILL NEED

Water colours:
 aureolin
 Indian yellow
 madder red dark
 rose madder genuine
 Winsor red
 cobalt blue
 French ultramarine
 manganese blue
 manganese violet
 brown madder
White gouache
Water sprayer
Masking fluid and an old brush
Nos. 10, 12 and 16 round brushes
No. 3 rigger brush
Bristle brush
Paper towel

1 Draw in the basic outlines for the composition. Use masking fluid and an old brush to mask the highlights on the boat and dinghy, the figures and the boat on the harbour wall, along the top of the low wall and the lamp. Spatter a few spots on the water below the harbour wall, then mask the edges of the reflections and the edge of the water against the harbour wall. For this project I tinted the masking fluid with a touch of rose madder (a non-staining colour).

2 Prepare the initial washes: Indian yellow, aureolin, manganese violet, manganese blue, brown madder, rose madder genuine and cobalt blue.

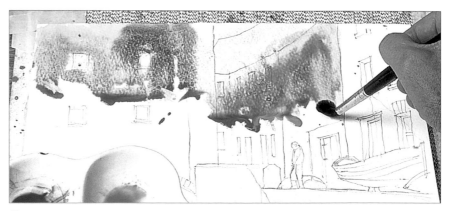

3 Spray clean water over the top of the paper, then, working quickly wet in wet, start to lay in the initial washes of colour.

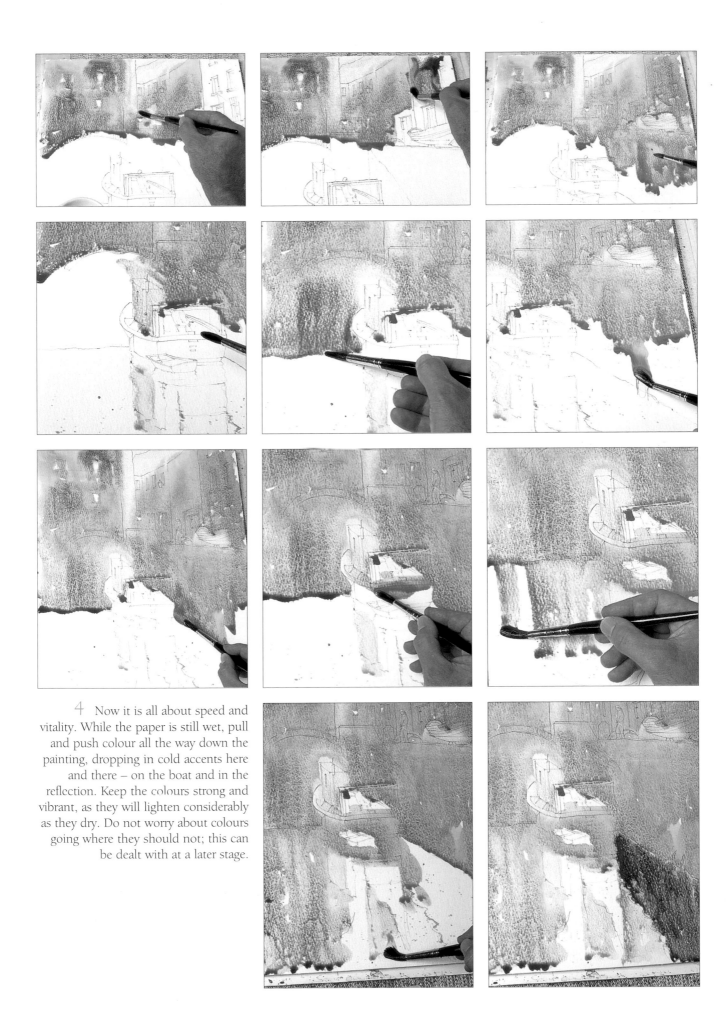

4 Now it is all about speed and vitality. While the paper is still wet, pull and push colour all the way down the painting, dropping in cold accents here and there – on the boat and in the reflection. Keep the colours strong and vibrant, as they will lighten considerably as they dry. Do not worry about colours going where they should not; this can be dealt with at a later stage.

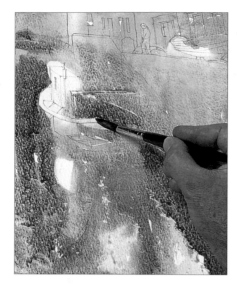

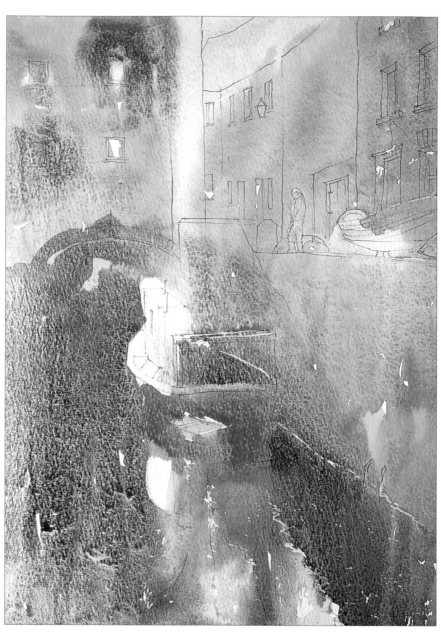

5 Complete the initial washes by adding colour to the boat, then leave until thoroughly dry.

6 Using the No. 12 brush with cobalt blue and brown madder, and working wet on dry, work up the shadowed wall of the building at top left, cutting round the windows. Add touches of manganese violet but leave some of the background colours as highlights on the stonework.

7 Work the darks under the arch with French ultramarine, cobalt blue and brown madder. Pull down the darks in the wet bead of colour above the arch to suggest brickwork.

8 Bring the colours down to the water's edge, then introduce cooler tones at the left-hand side. Cutting round the shape of the boat, use the same colours to create the cast shadow on the harbour wall, but add more blue as you work forward.

9 Use Indian yellow and brown madder to paint the sunlit walls of the buildings at top right; again, cut round the windows and leave some of the undercolour shining through. Add touches of manganese blue here and there to cool some areas. Use cooler tones to add the distant buildings at the top left corner of the composition.

10 Use the same colours but with more Indian yellow to work up the right-hand building. Use manganese violet to paint the two doors.

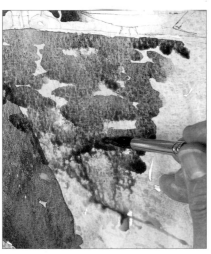

11 Spatter water on the harbour wall then, using cobalt blue and brown madder, touch a loaded brush gently on the paper and allow the colours to disperse randomly creating hard and soft edges.

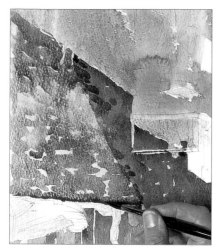

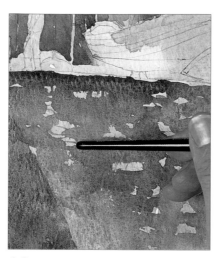

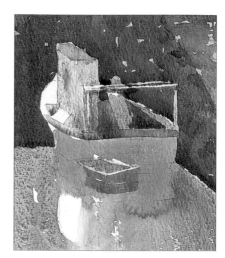

12 Spatter aureolin and manganese blue on the lower part of the wall, followed by brown madder and cobalt blue just above the water line. Turn the painting upside down and drop in more colour and allow a bead to form to define the hard edge along the top of the harbour wall.

13 While the colours are still wet, use the handle of the brush to indicate mortar joints between the blocks of stone, then leave to dry.

14 Use manganese blue and manganese violet to paint the left-hand side and back of the boat's superstructure, and the inside of the dinghy. Use brown madder, cobalt blue and a touch of manganese violet for the shadows in the stern of the boat. Paint the cabin roof with aureolin and madder red dark. Use brown madder to paint the side and stern of the dinghy, then add a touch of cobalt blue to the brown for the reflection.

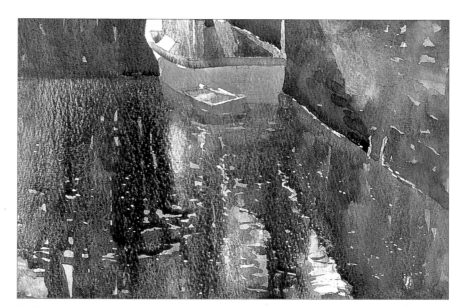

15 When I laid in the initial washes, I allowed some colour to spread over the boat on the harbour wall. On reflection, this should be removed. Use a small bristle brush and clean water to wet the unwanted colour, use a clean piece of paper towel to lift it off the paper, then use manganese blue and manganese violet to block in the side and inside stern of the boat.

16 Brush a few vertical bands of clean water on the area of water, then, starting at the water line against the far building, lay in reflected colours with touches of cobalt blue, brown madder and manganese violet and allow them to blend. Add a few horizontal squiggles in the foreground. Drop some French ultramarine and aureolin into the reflection of the harbour wall at the right-hand side. Apply a weak cool wash over the orange reflection of boat. Referring to step 13, use the handle of the brush to create fine ripples in the reflections. Leave to dry completely.

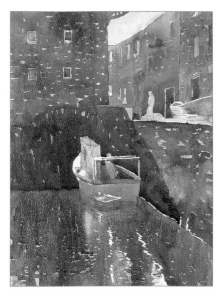

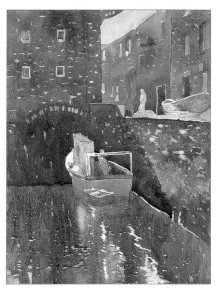

17 Remove all the masking fluid to reveal the saved whites.

18 Referring to step 15, use clean water, a bristle brush and paper towel to soften some of the hard edges created by the masking fluid on the water and the boat. Lift out colour from the windows and from the brickwork in the arch and harbour wall. Spatter water over the harbour wall, leave for a few seconds, then lift out some of the colour to create small areas of soft highlights.

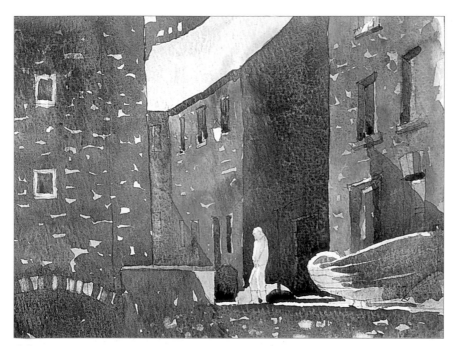

19 Use a No. 12 brush and a weak wash of cobalt blue with touches of manganese violet and brown madder to block in the shadowed end of the middle building and the cast shadows on this and the right-hand building. Use a dry brush to lift off excess colour from bottom edges. Use a No. 10 brush to paint shadows under the eaves and in the windows, on and under the boat on the harbour wall and across the end of the low wall.

20 Using a No. 16 brush with French ultramarine, cobalt blue and brown madder, and starting at the top of the left-hand building, pull the colours down the paper to the bottom of the wall. Cut round the boat shape. Bring the same colours down through the water with broad vertical strokes, then work some narrow horizontal ones. Add a few squiggles of darker tones in the bottom right-hand corner. Leave until the paint is completely dry.

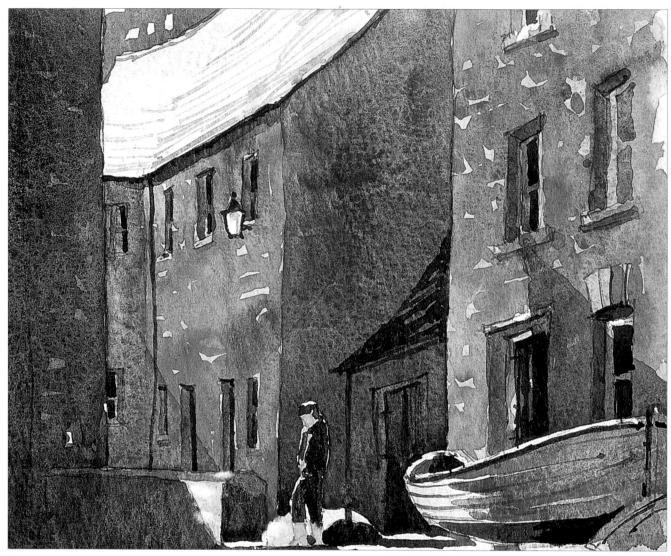

21 Dipping into each colour in turn, load a No. 3 rigger with French ultramarine, brown madder and cobalt blue, then add dark shadows under eaves and round the windows and doors. Use the same colours to develop the shape of the lamp and the roof of the lean-to between the buildings. Use cobalt blue and Winsor red to develop the dark shadows on the boat. Use the same colours to block in the clothes of the figure, leaving some of the undercolour as highlight. Use manganese blue to add texture on the roof, then add a touch of this colour to glass of the lamp. Use Indian yellow for the highlights on boat and the man's boots.

22 Add darks in the windows of the left-hand building. Indicate a few bricks over the windows and add the drain pipe. Develop the deep shadow under the arch and add a couple of dark patches on the low wall.

23 Apply a wash of Indian yellow on the white highlights on the boat. Using a dark mix on the palette, paint the mooring ring on the harbour wall and the mooring ropes. Develop the shadowed stern of the boat with Indian yellow, cobalt blue and a touch of brown madder. Darken the area behind the dinghy with more cobalt blue and develop the shadows with darks from the palette. Use manganese blue with a touch of Winsor red to paint shadows on the cabin, then use the darks on the palette to define detail inside the hull of the boat. Add the same darks to the reflections at bottom right.

24 Finally, use white gouache to add fine, bright highlights on all the mooring ropes.

The finished painting.

93

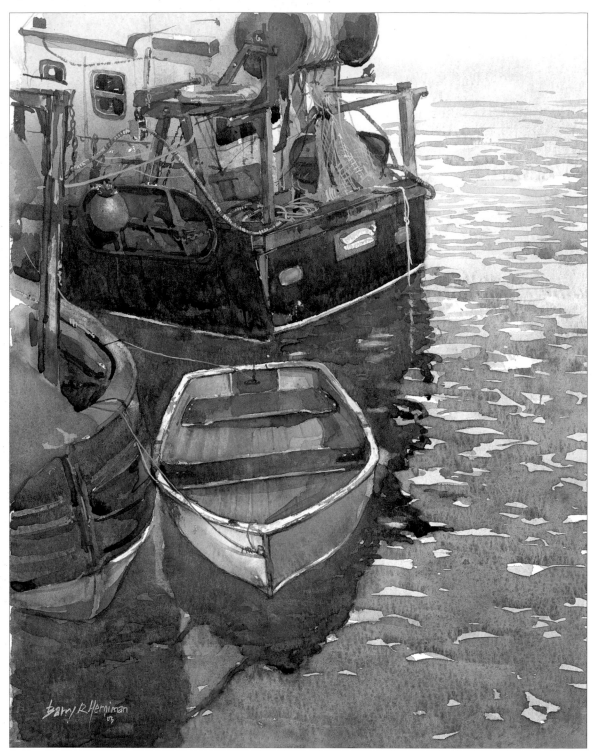

New Coat of Paint, Stornaway Harbour

Size: 290 x 375mm (11½ x 14¾in)

Stornaway harbour, on the Isle of Lewis, always has a whole host of magnificently coloured fishing boats moored up for the night. On this visit, my eye was drawn to this small rowing boat tied up behind the fishing boats and lying in their shadow. It was in the process of being painted blue, hence the two-tone hull!

Boats make wonderful subjects, but they can be quite daunting when you first look at all the lines and details. I tend to simplify things a lot; I concentrate more on the main structures then, when I am happy with those, I use a rigger brush to 'tick' in a few fine details.

Opposite

Morning Light, Tenby Harbour

Size: 350 x 535mm (13¾ x 21in)

Whenever I visit Tenby, I endeavour to take an early morning walk around the harbour. At low tide, you can walk on the sand between the tied up boats. From this viewpoint, looking up at the boats and the buildings beyond, you get a completely different slant on the scene. The small rivulets of water and the crisscross pattern of the mooring ropes and chains make a pleasing detail in the foreground that helps lead the eye into the picture. The main area of light is between the two buildings, top left, and this reflects nicely into the water on the sand.

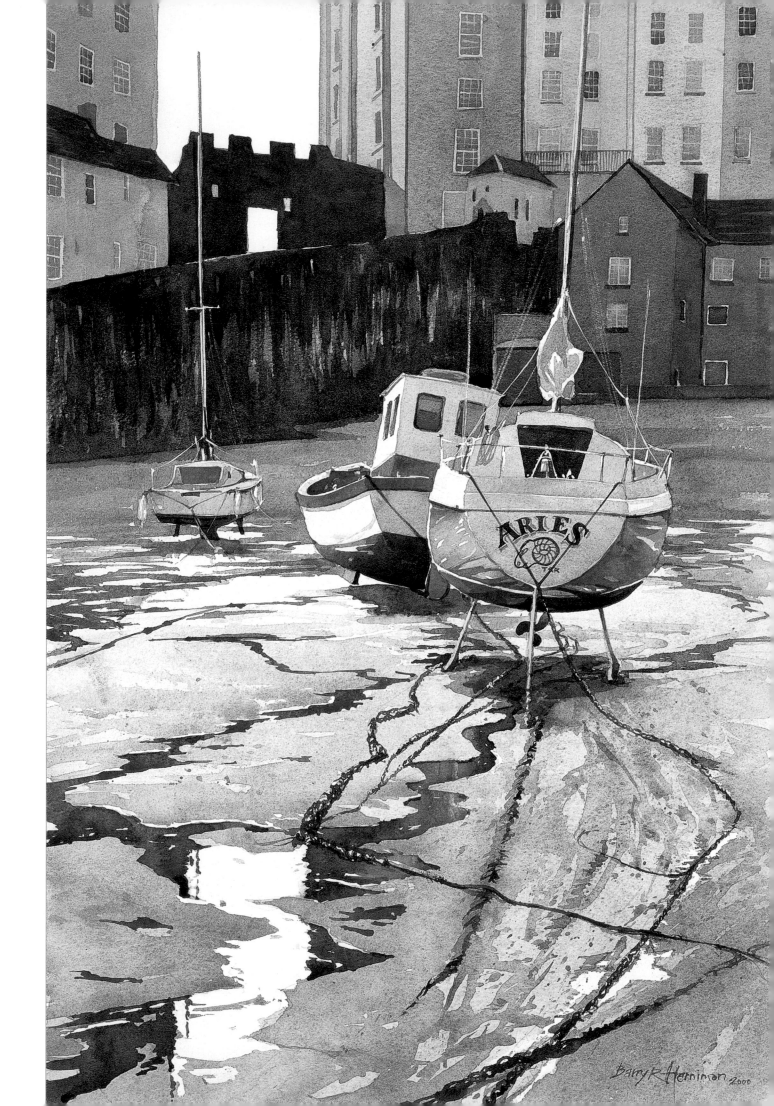

Barry R. Herniman 2000

Index

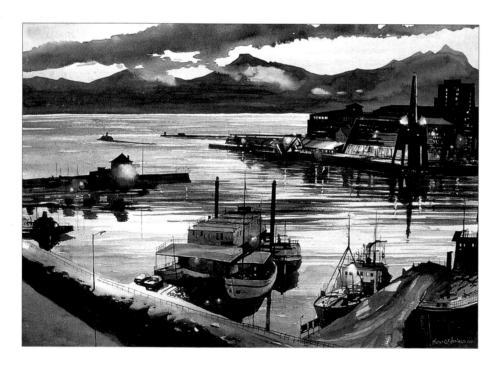

As Light as it Gets, Tromsø Harbour

Size: 685 x 485mm (27 x 19in)

The city of Tromsø is in the far north of Norway, above the Arctic Circle. I was only there for three days but in that time I never saw the sun; just this lovely glow around midday, then darkness again – most weird! Because of this, there are always lots of lights casting their multicoloured glows over the snow-covered land.